Add A Little Colour Mandalas

A colouring book
Created By
Ms Moem

© 2016 MS MOEM. ALL RIGHTS RESERVED.
ISBN 978-1-326-54827-8

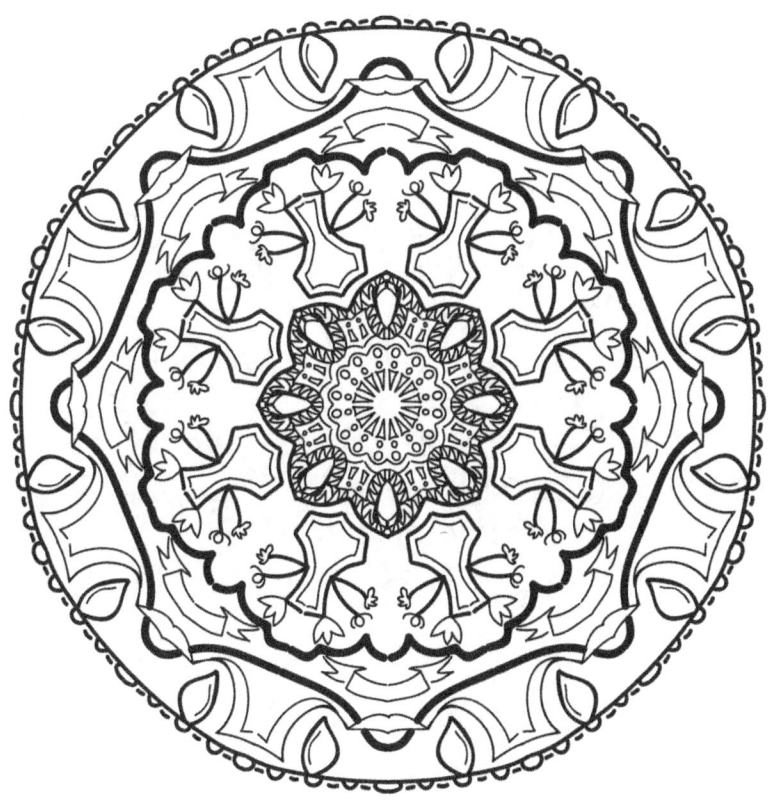

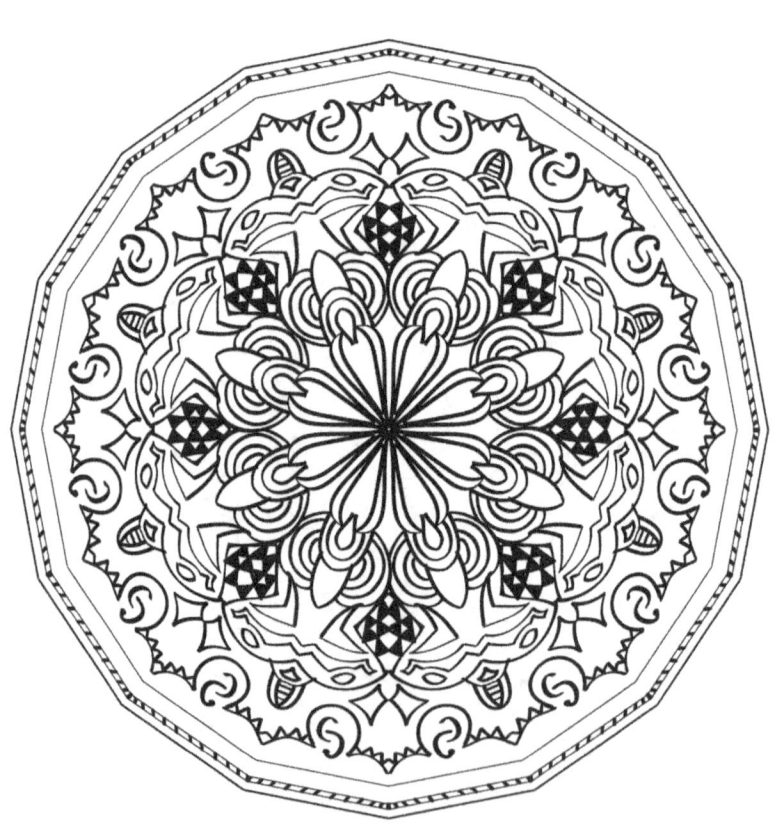

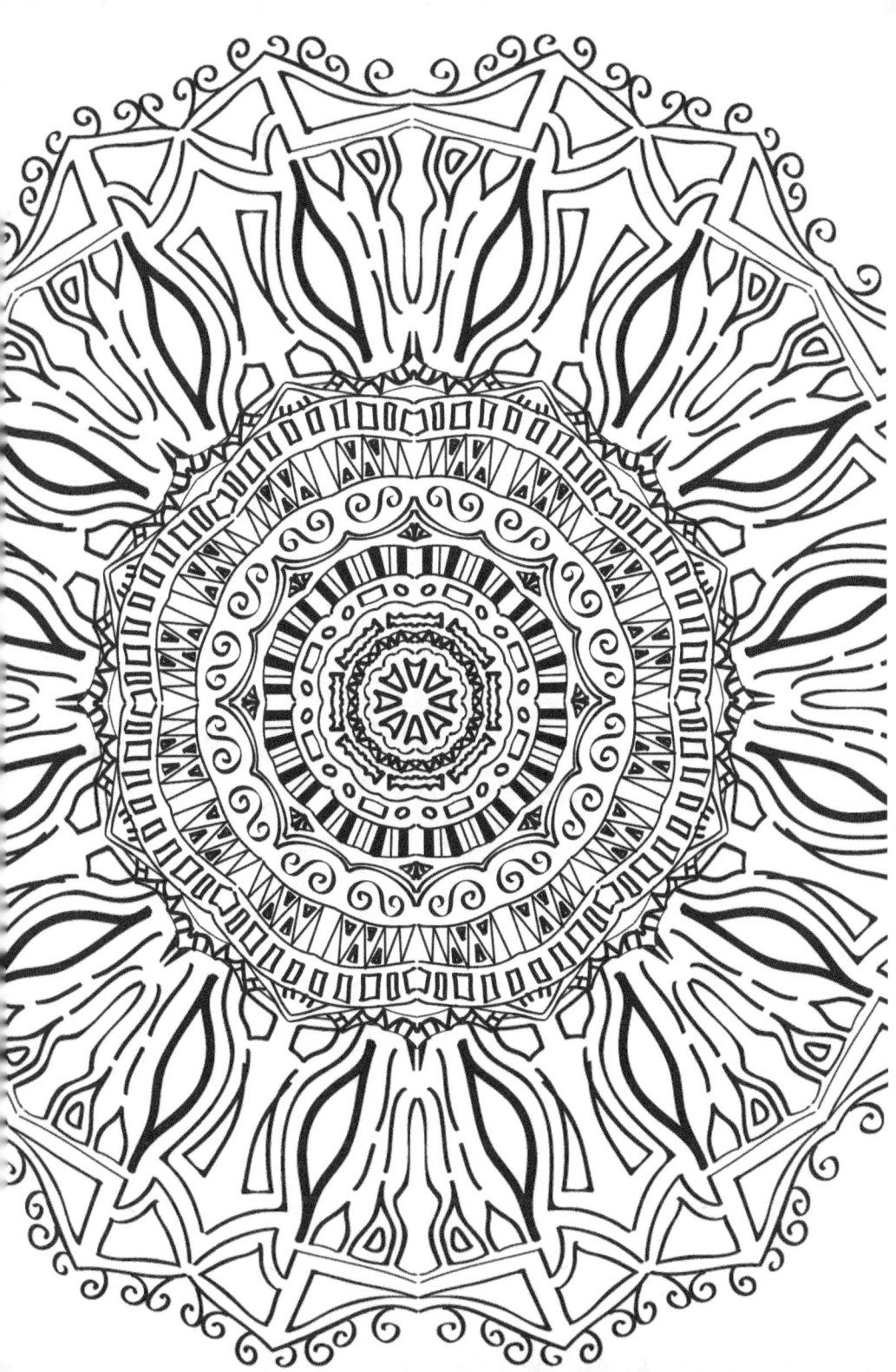

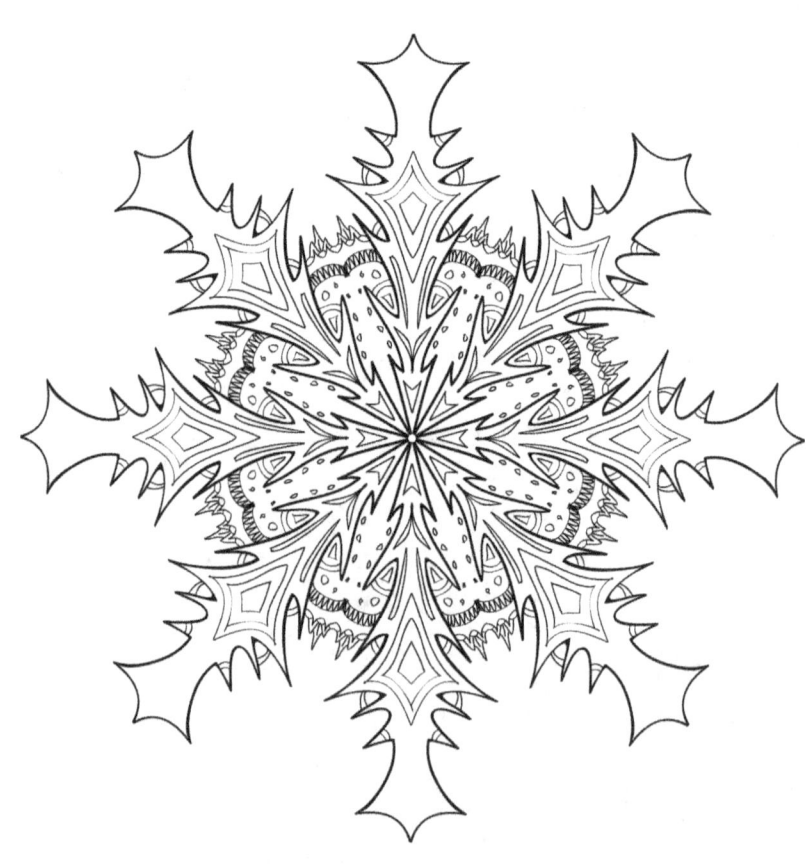

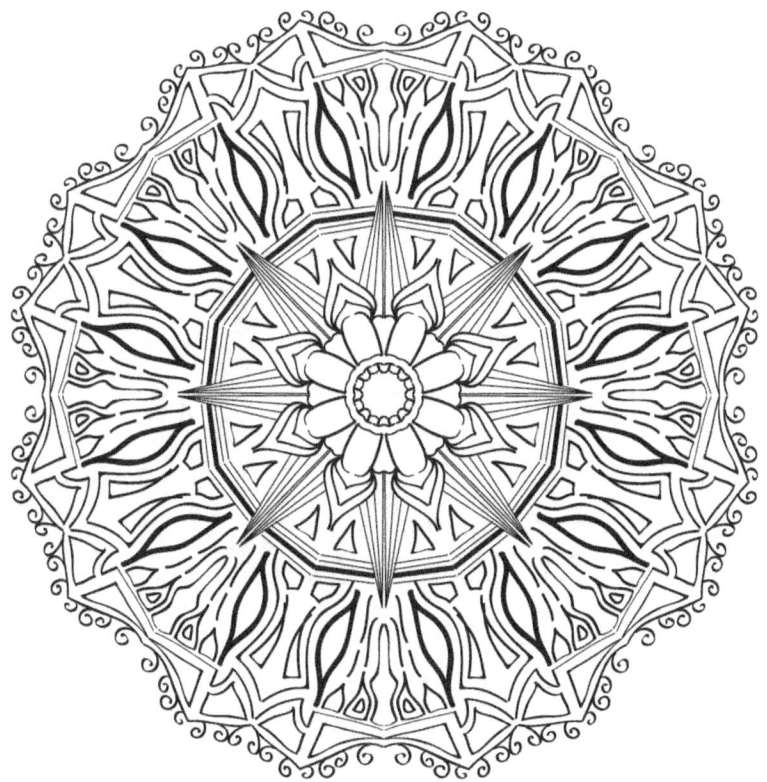

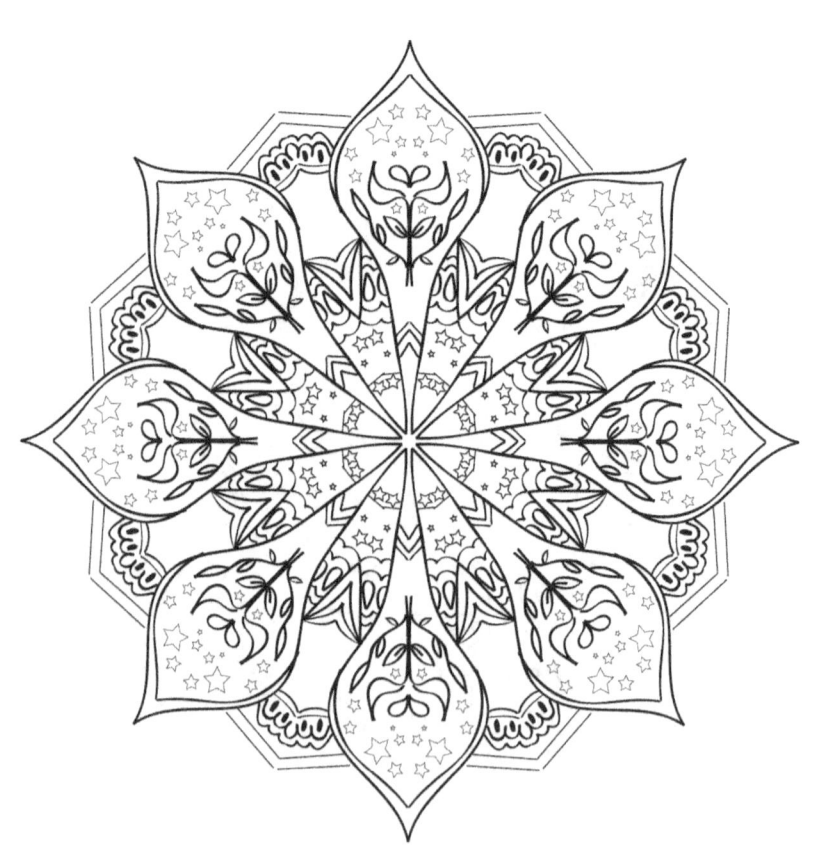

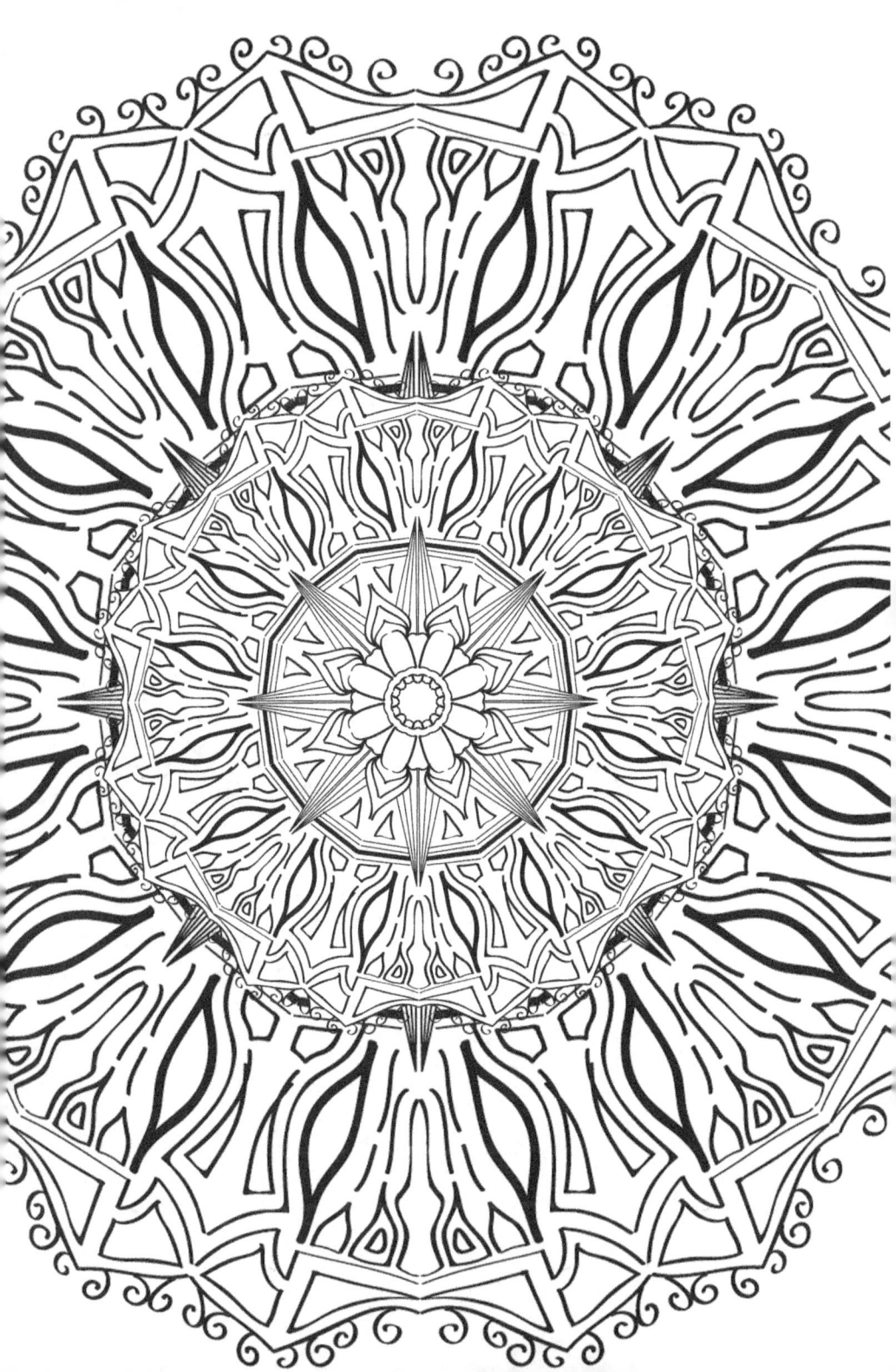

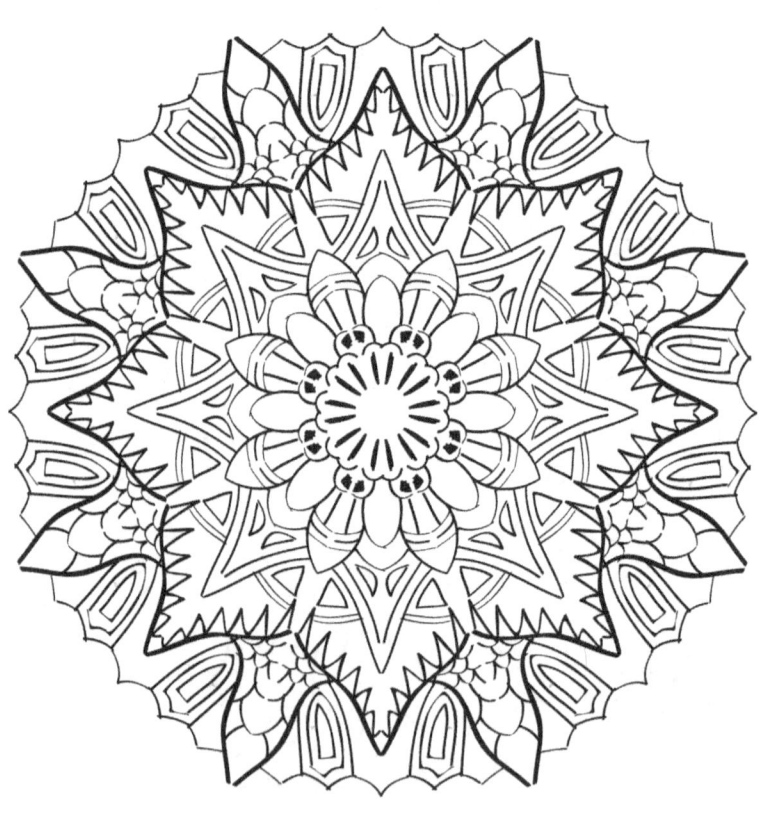

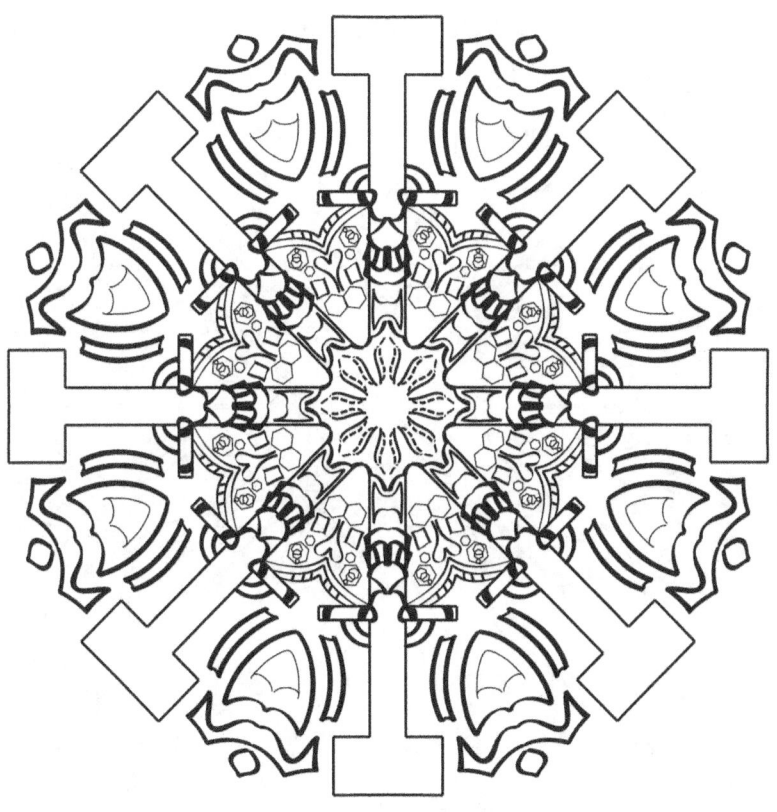

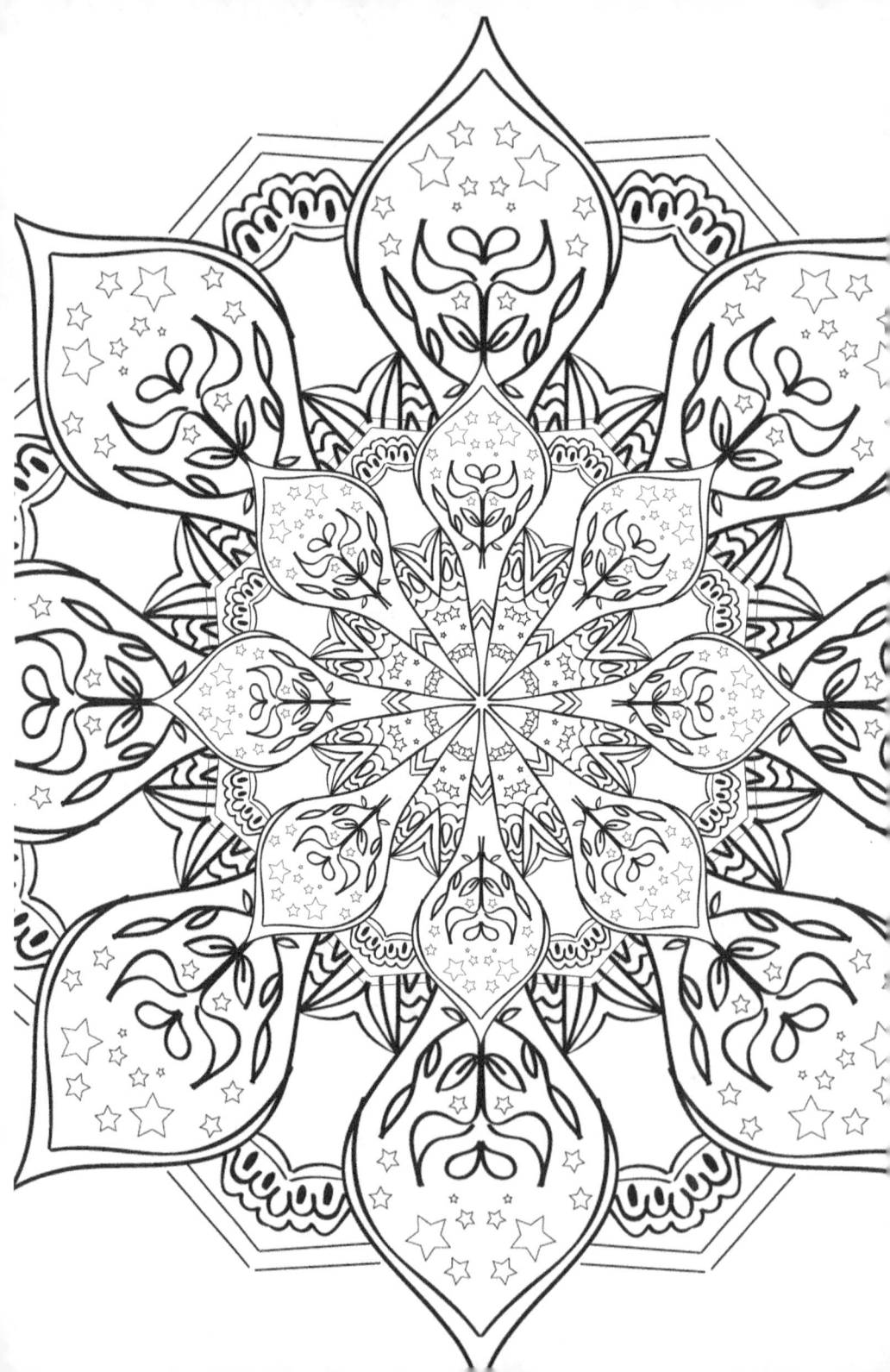

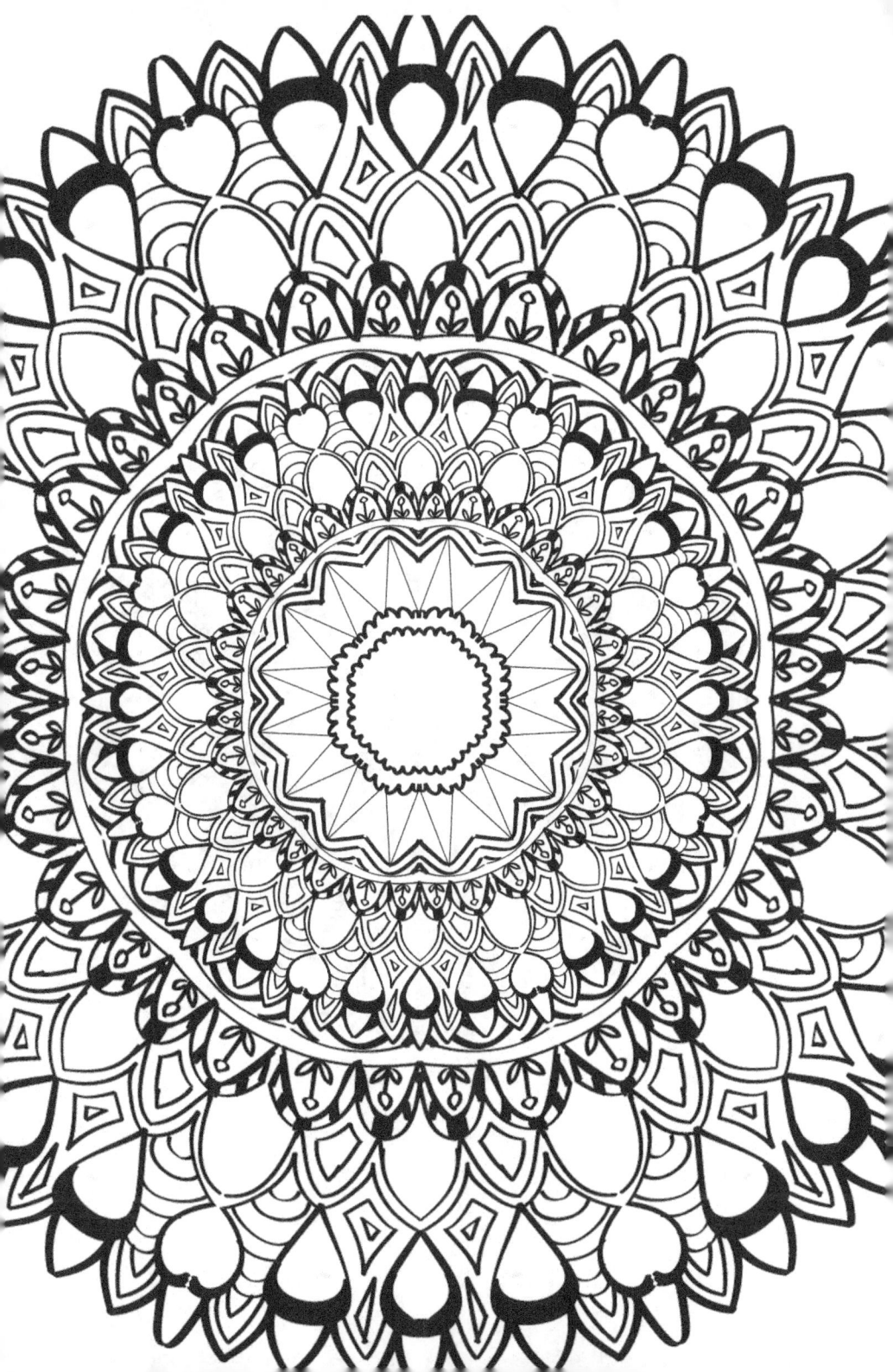

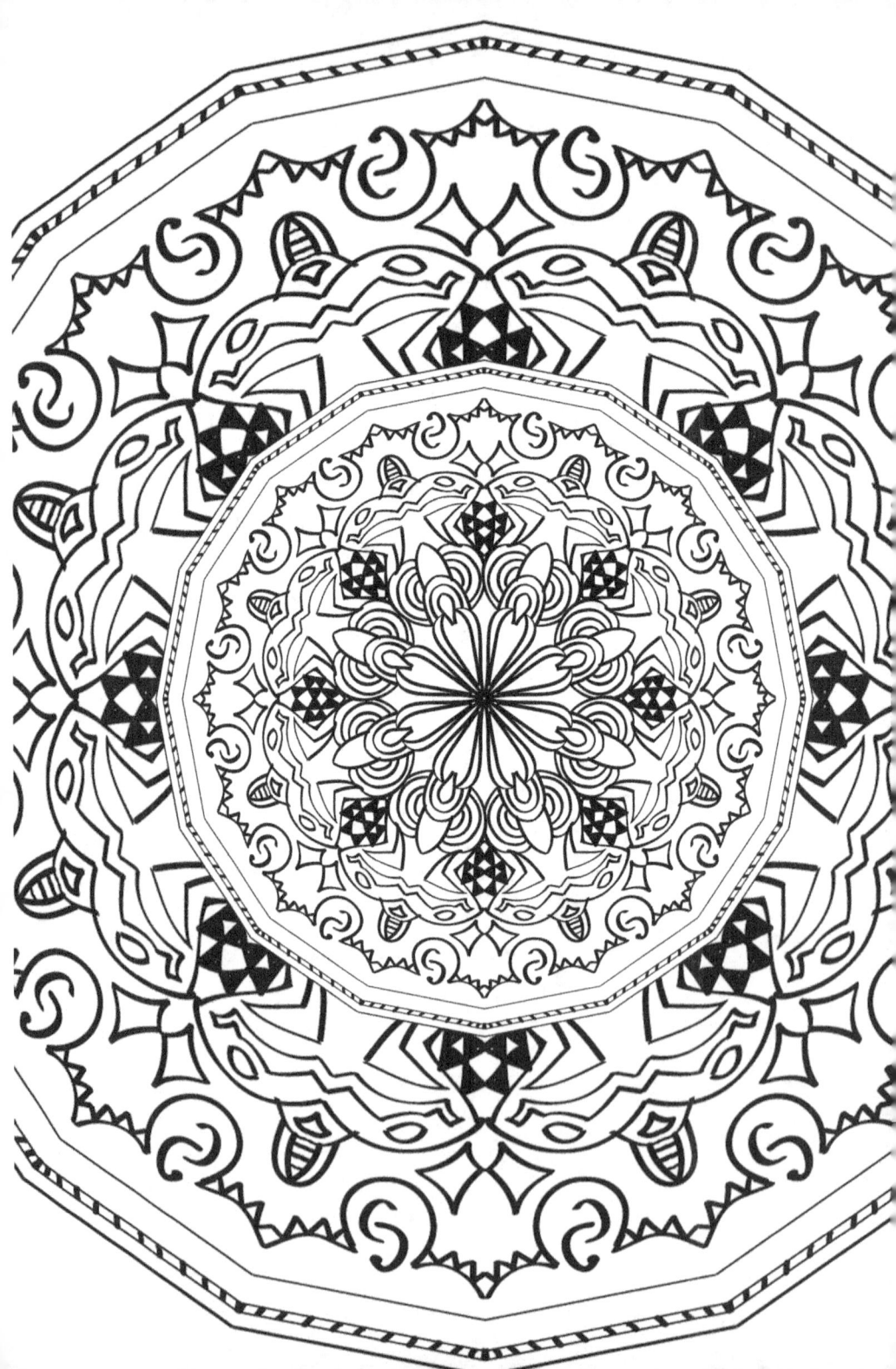

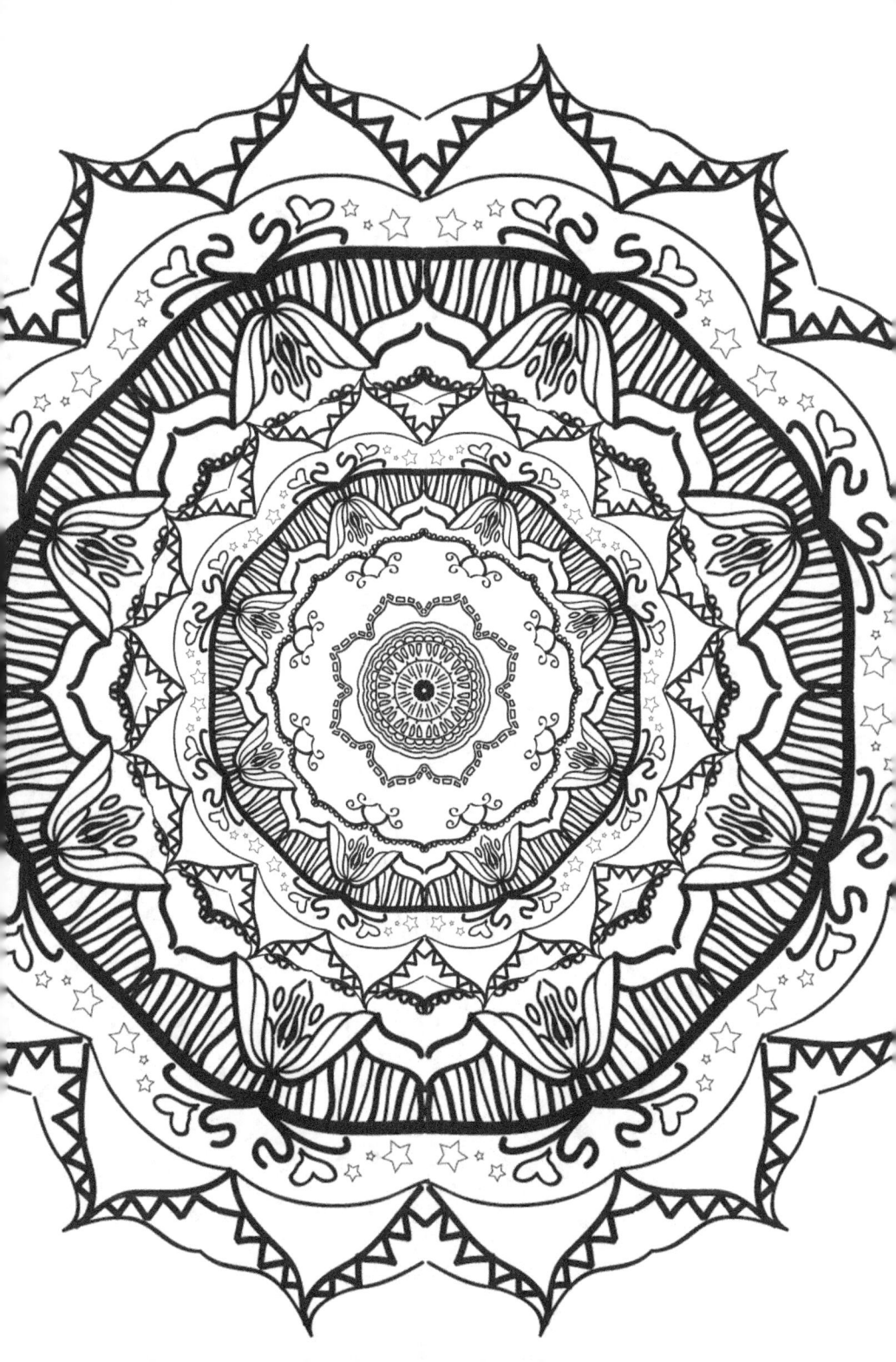

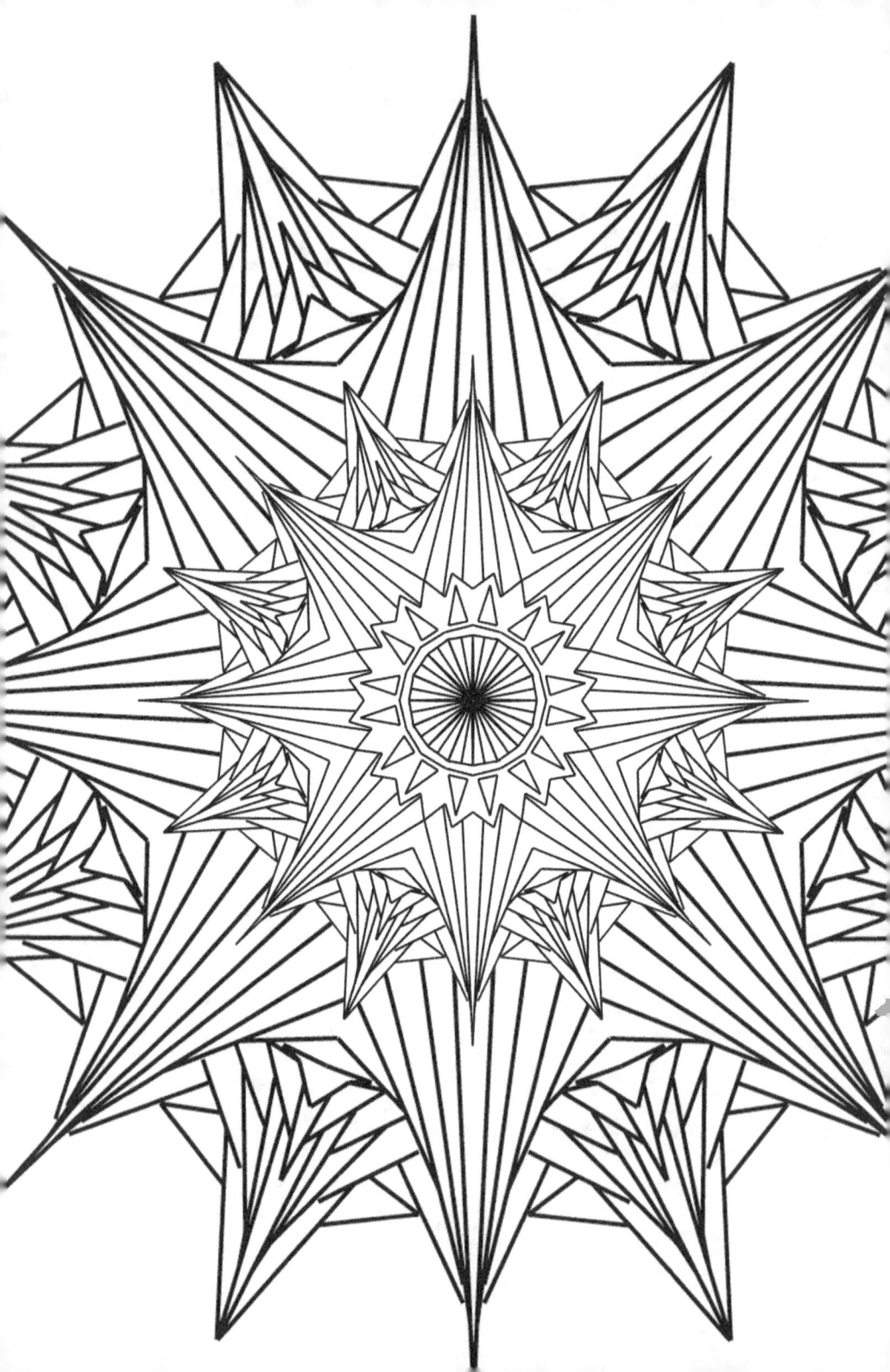

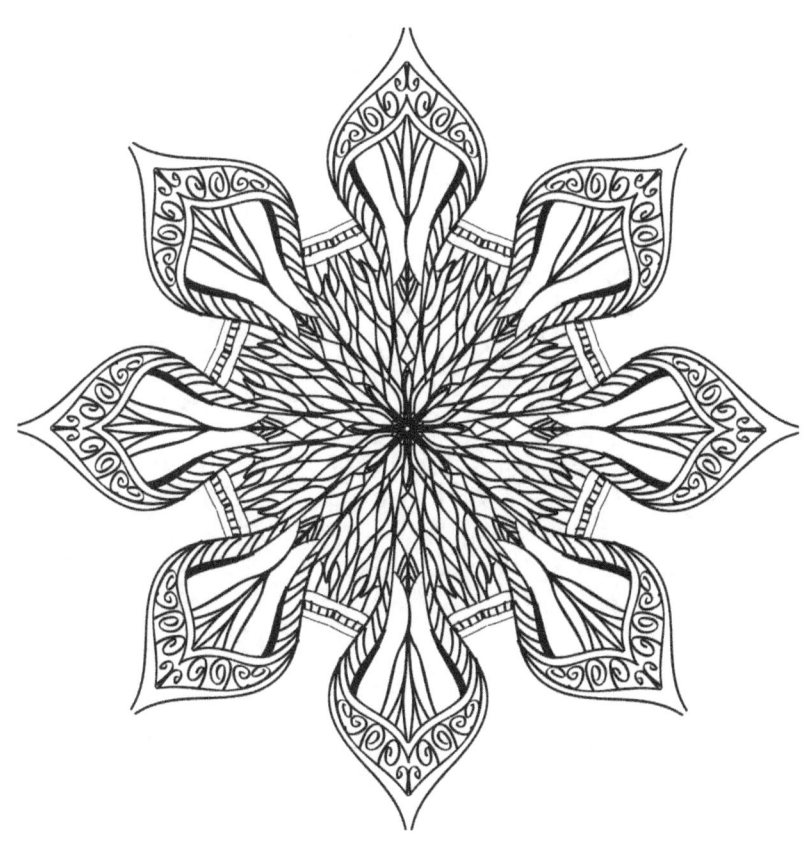

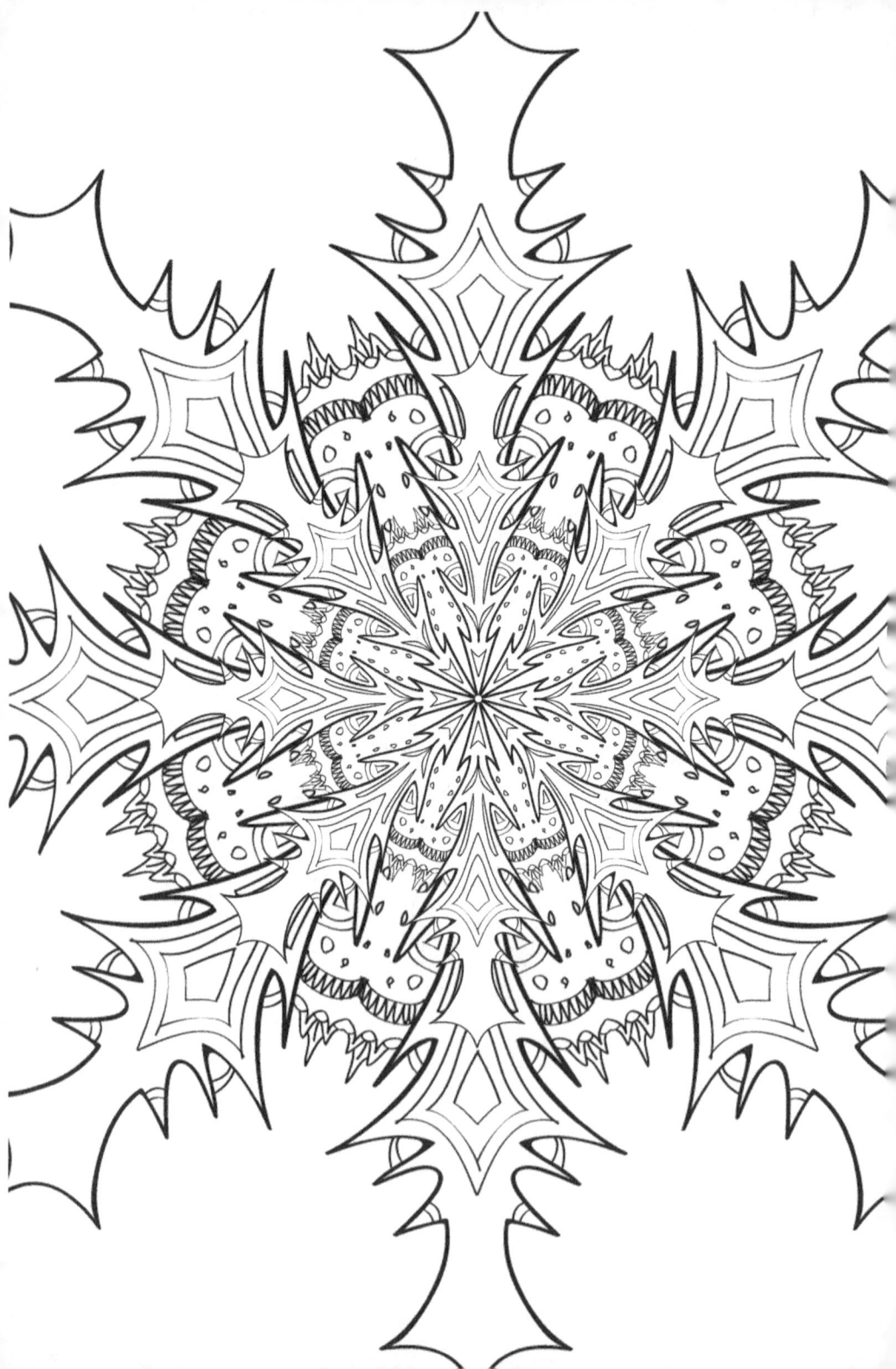

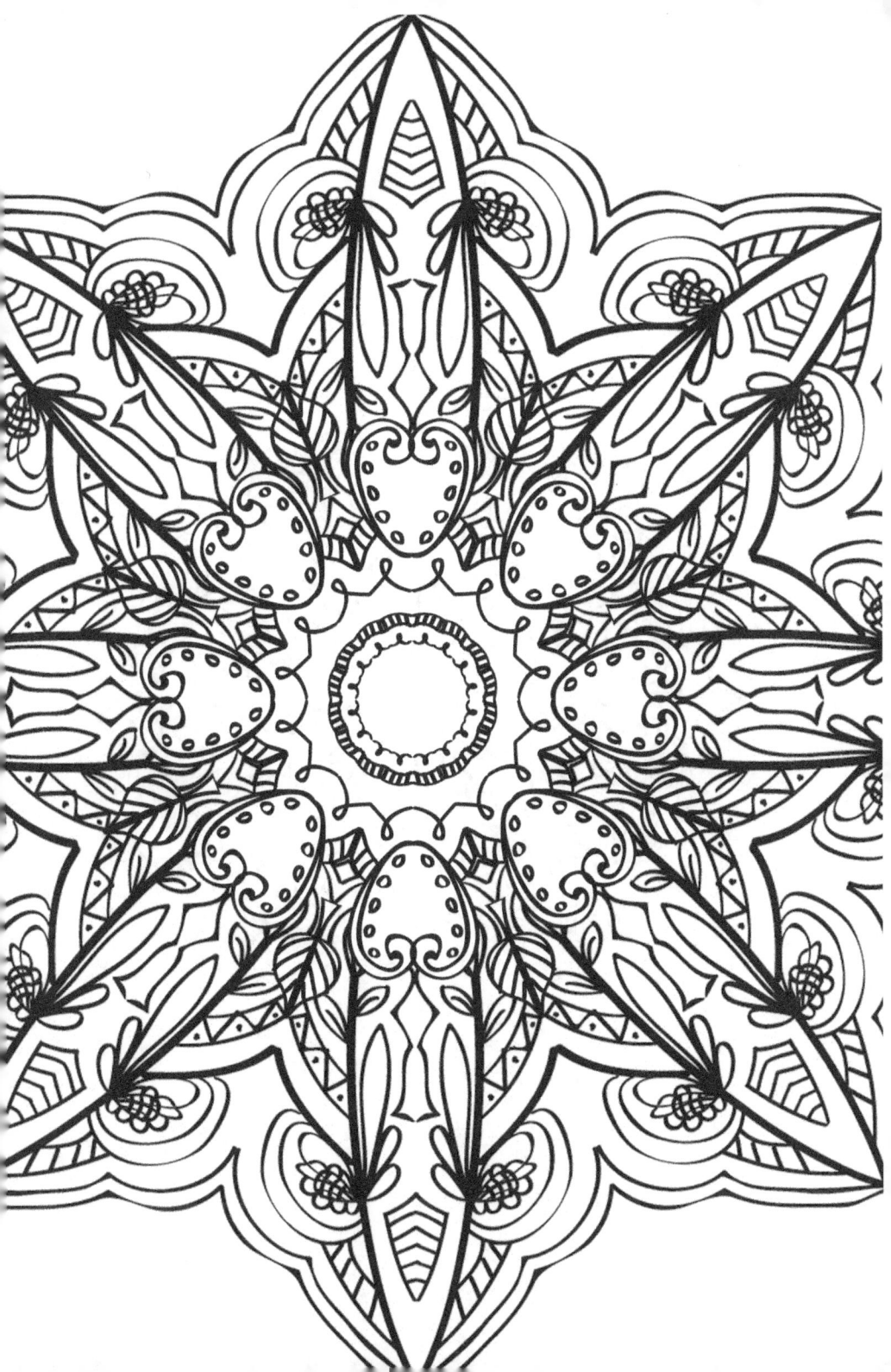

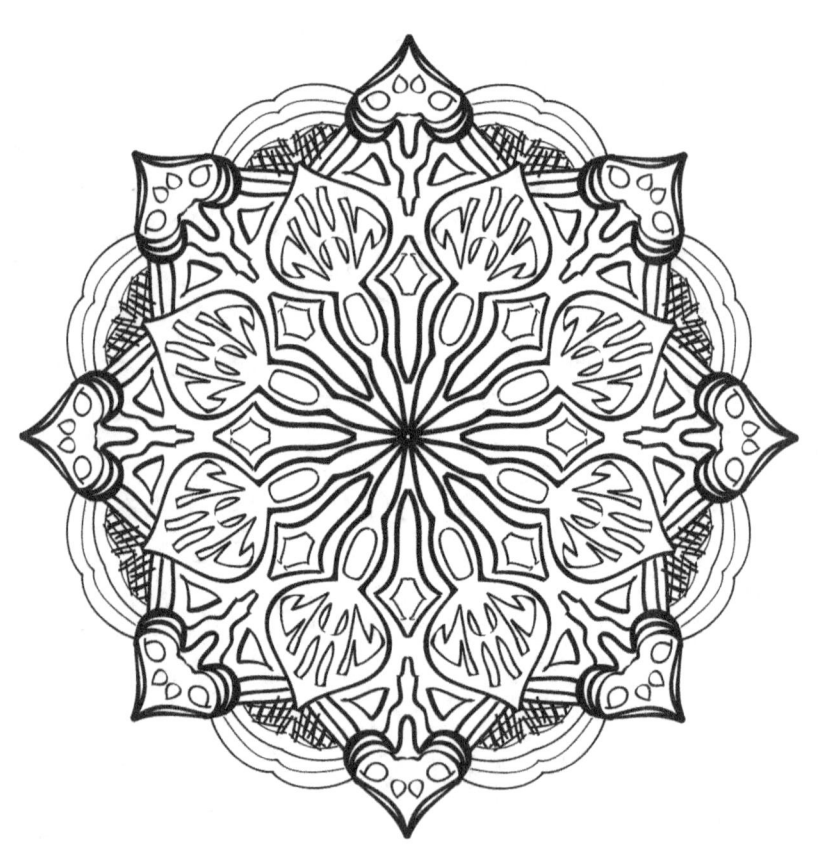

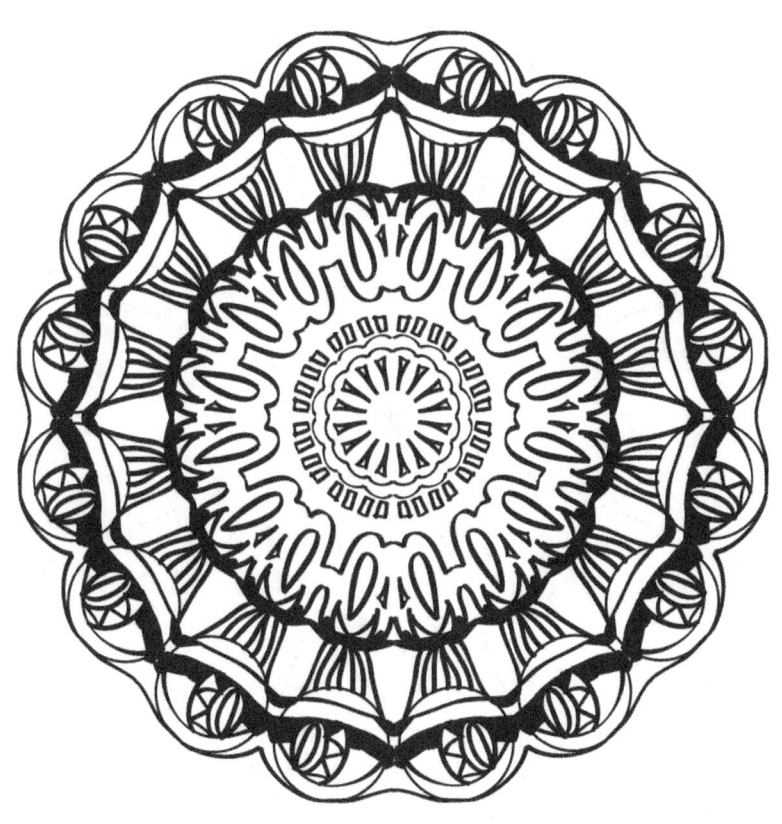

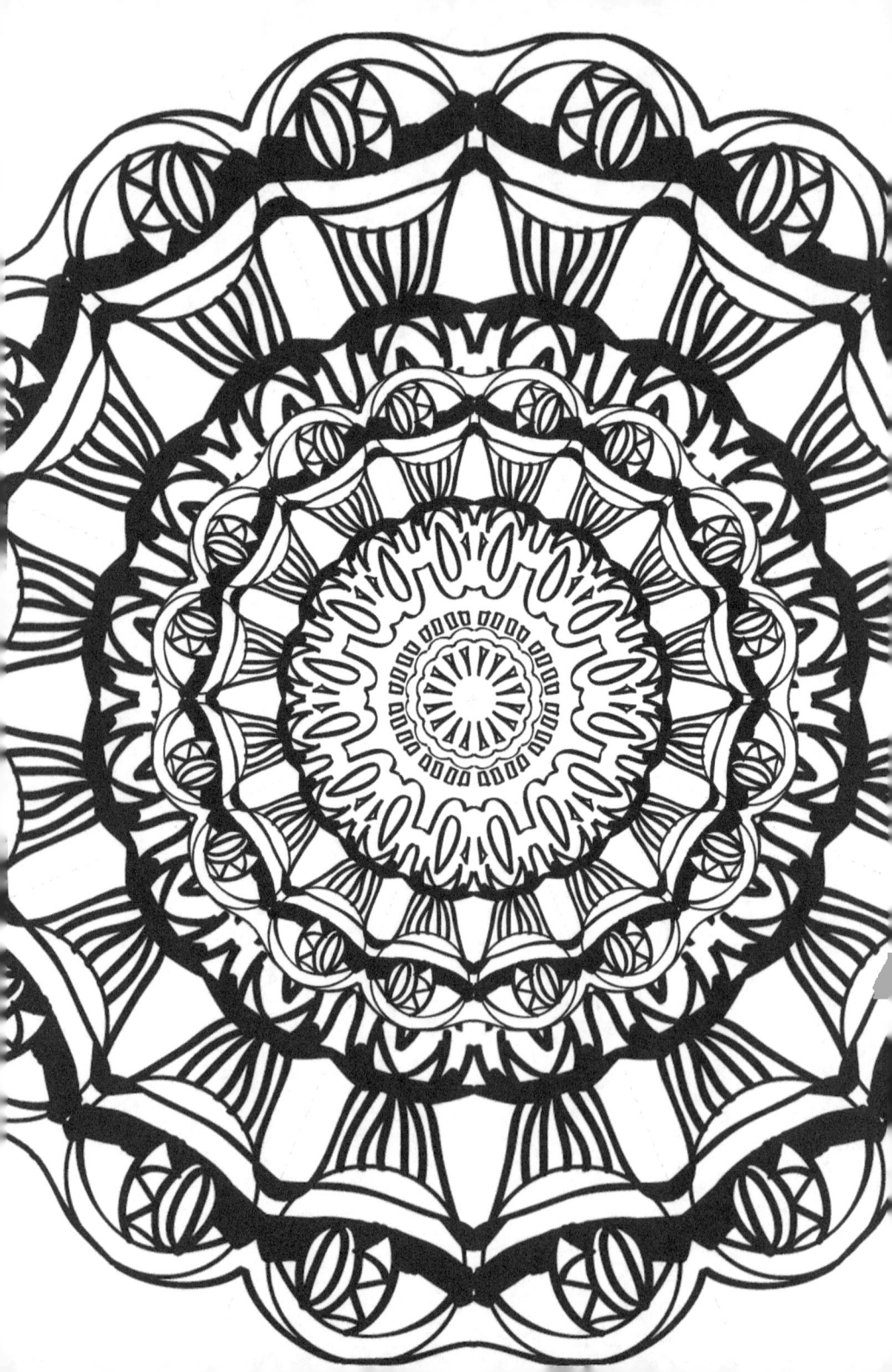

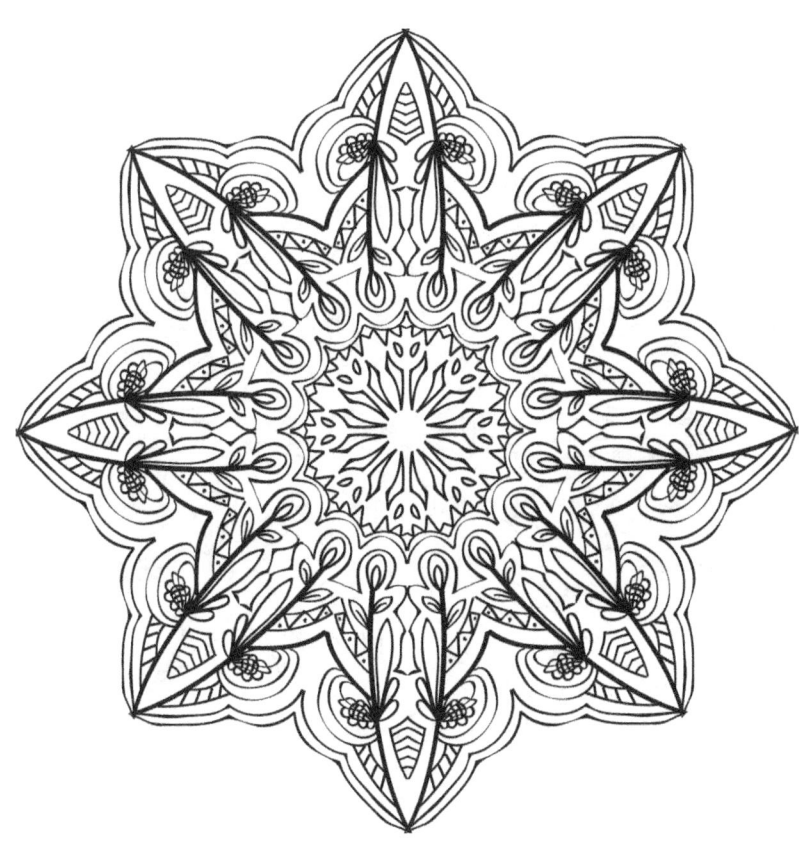

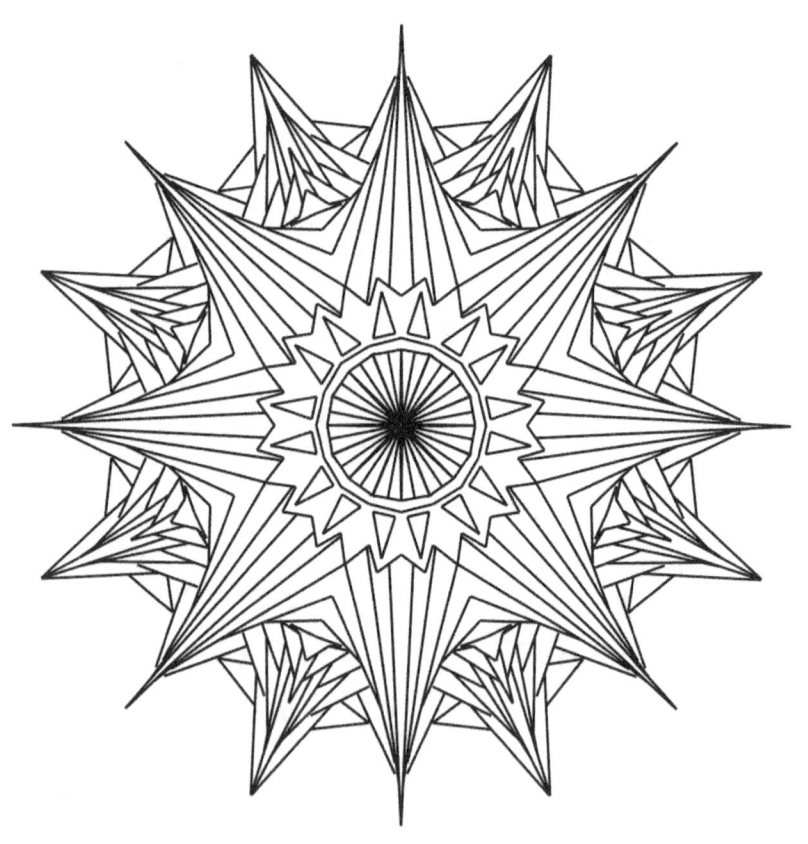

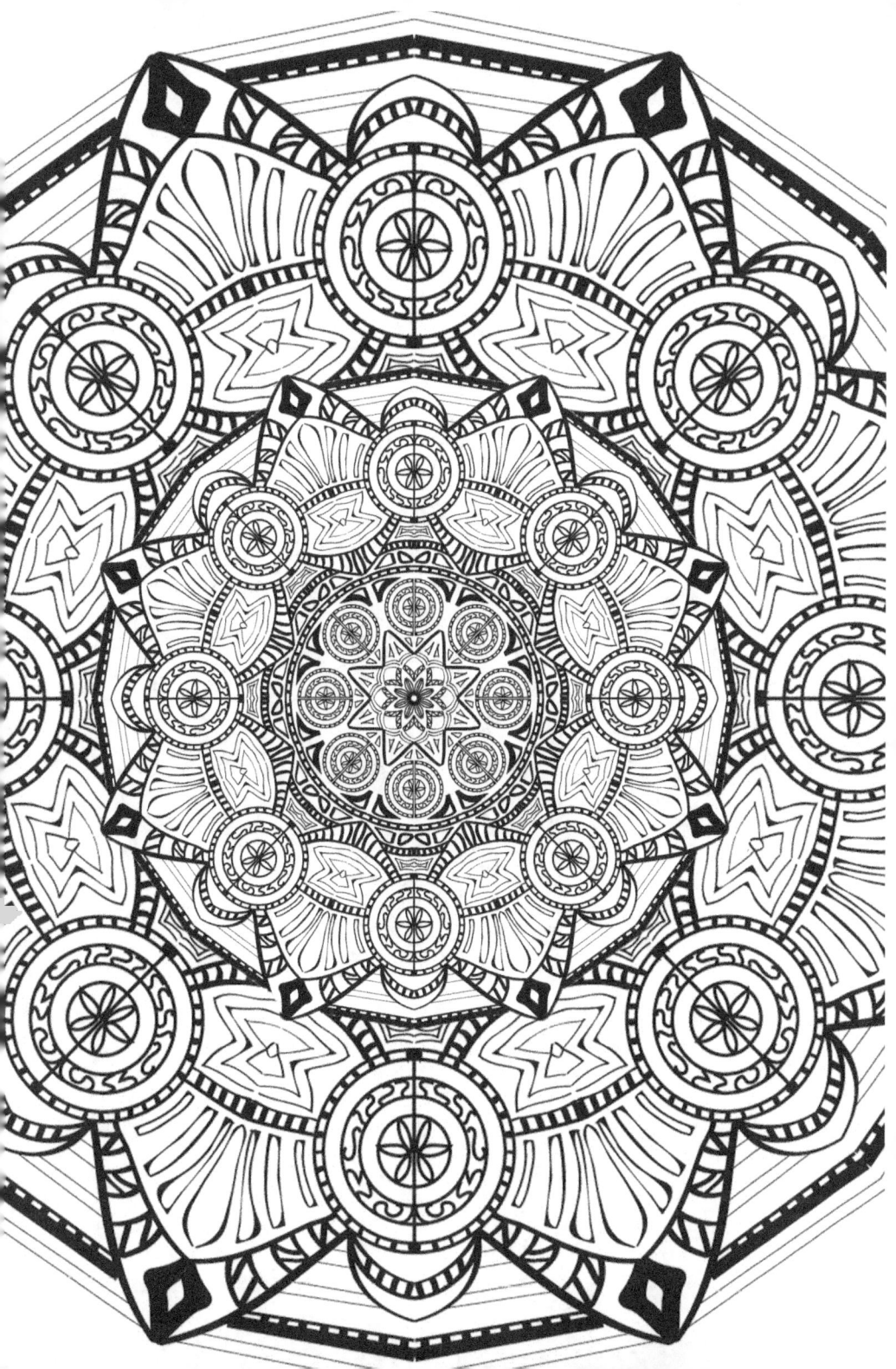

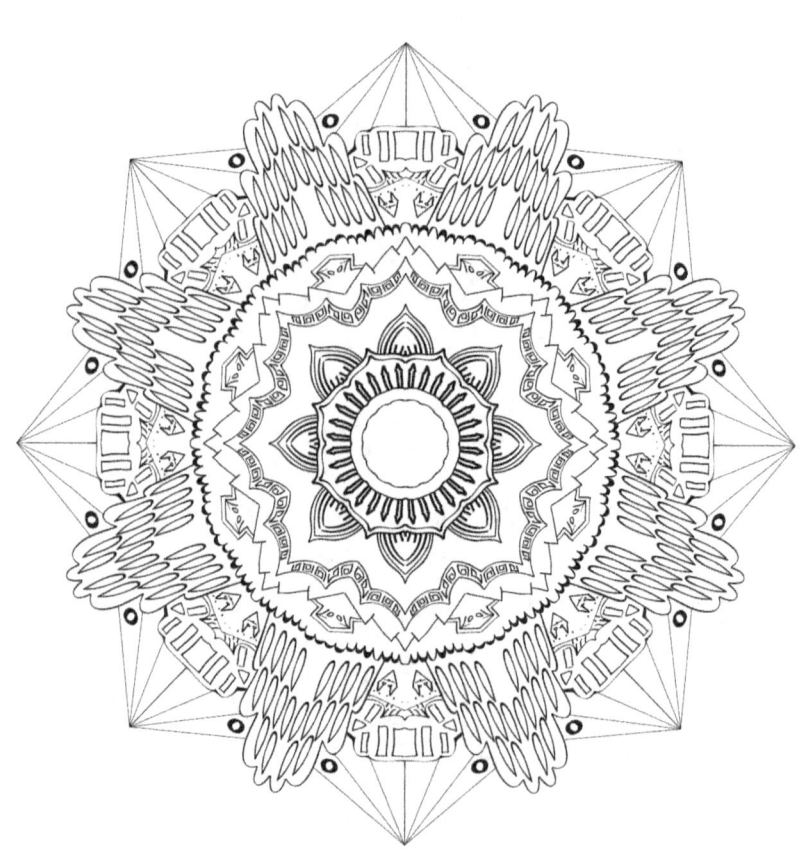

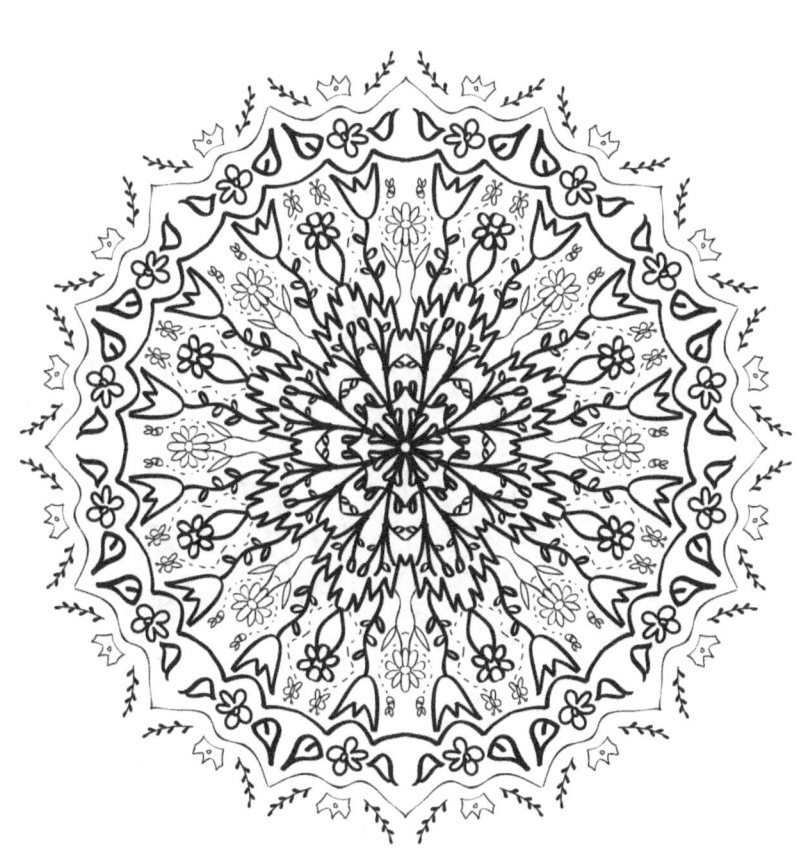

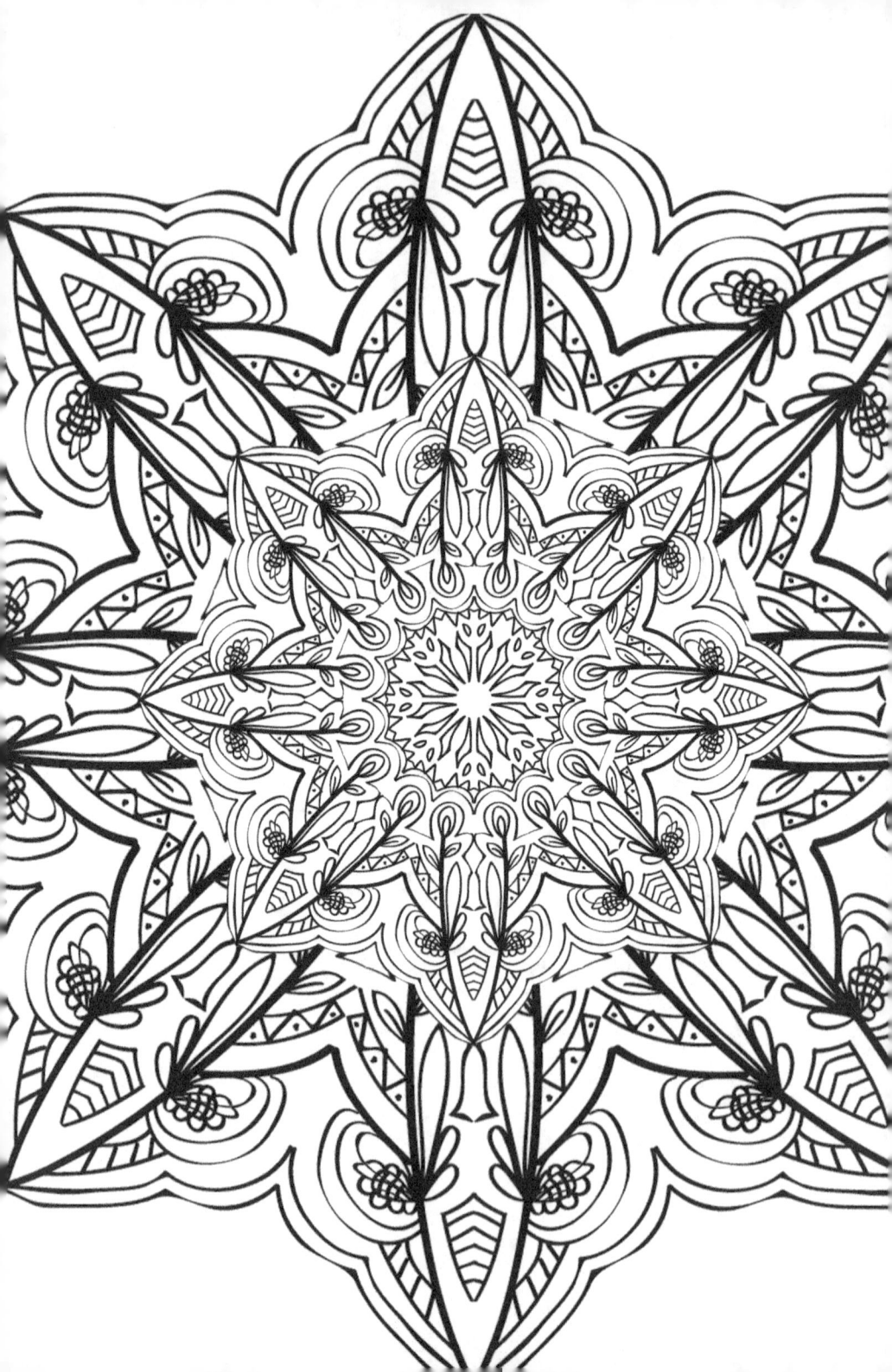

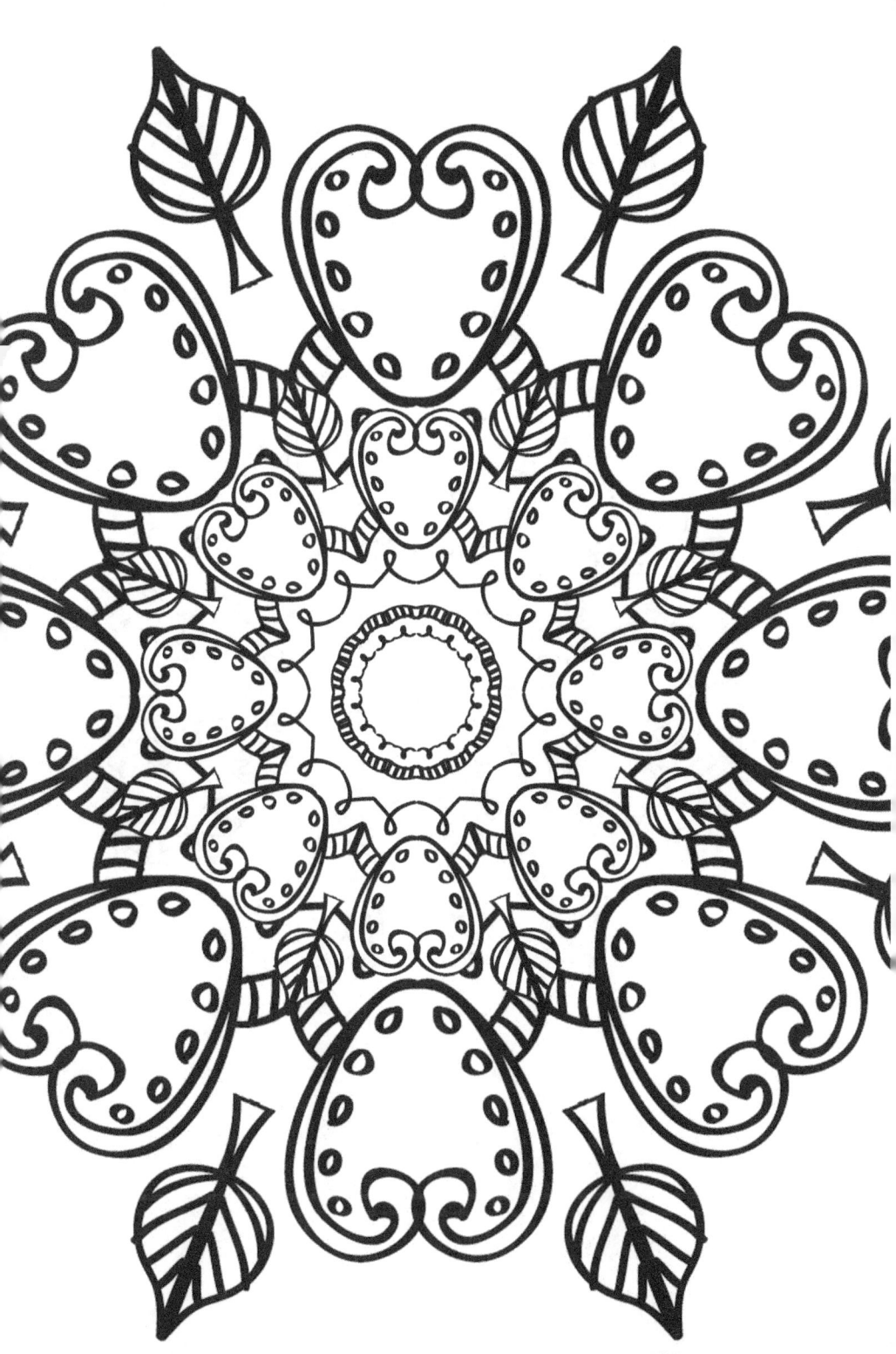

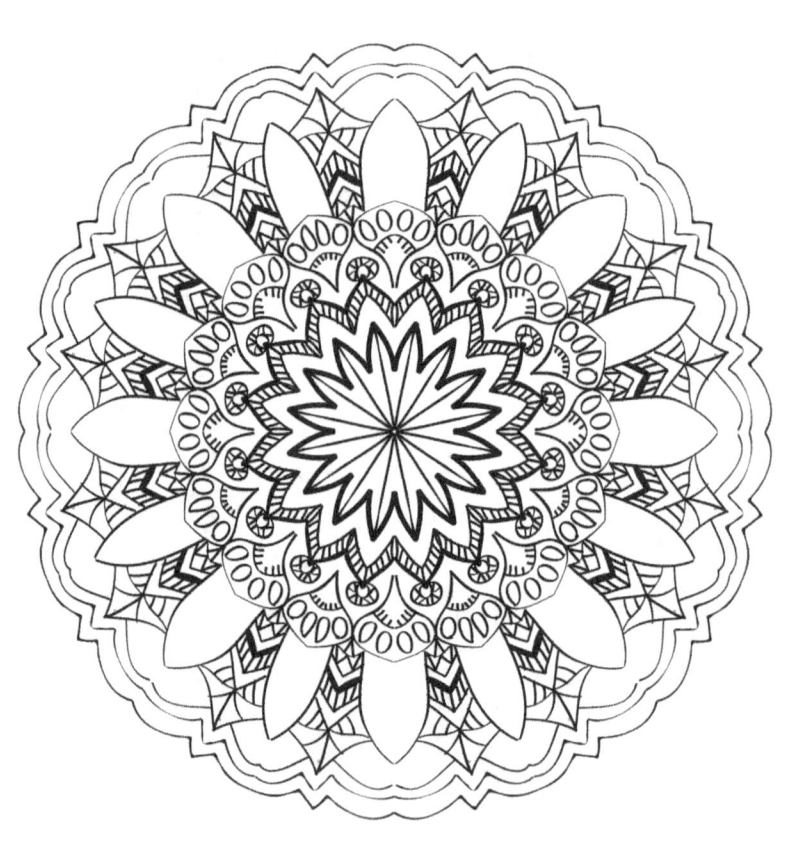

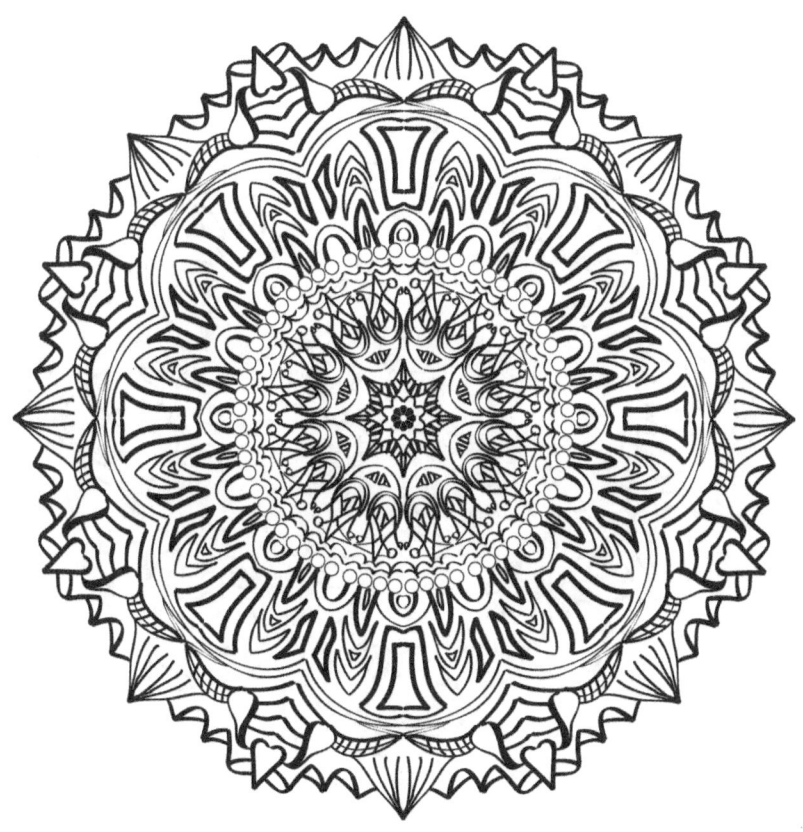

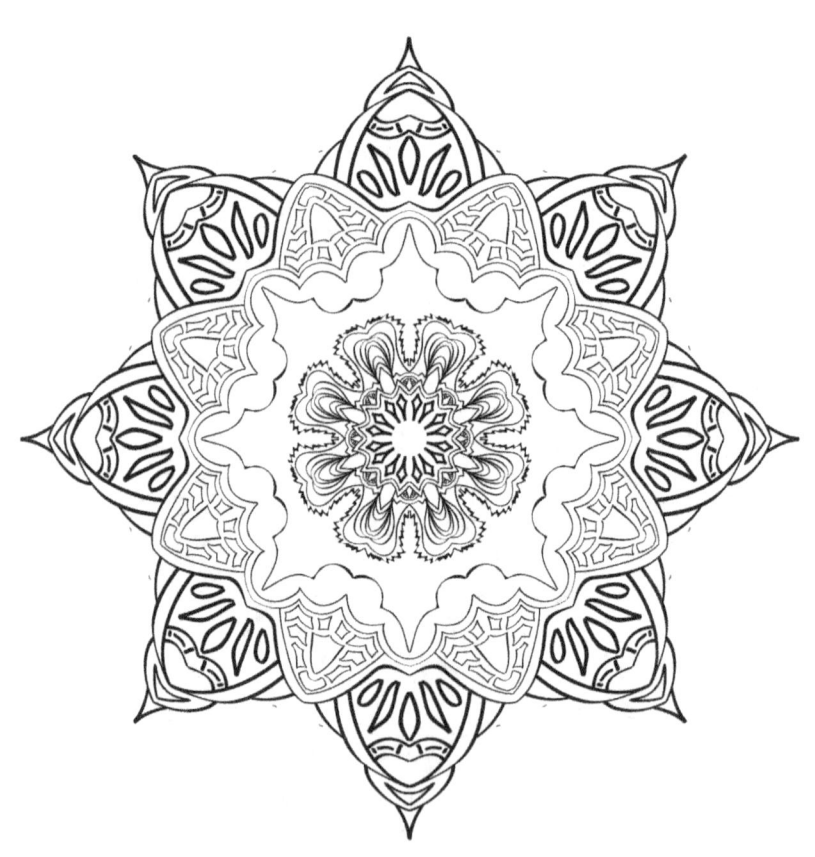

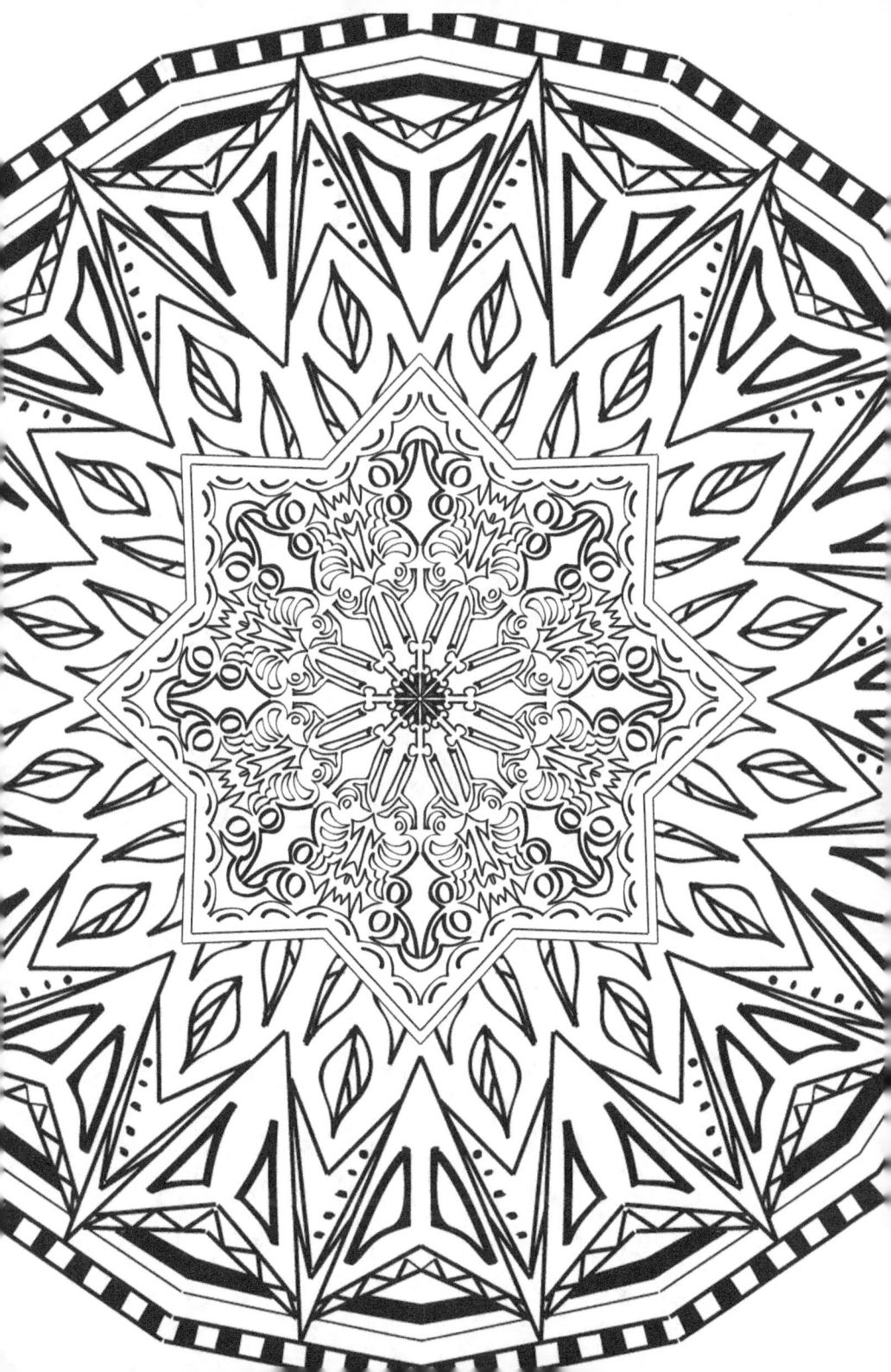

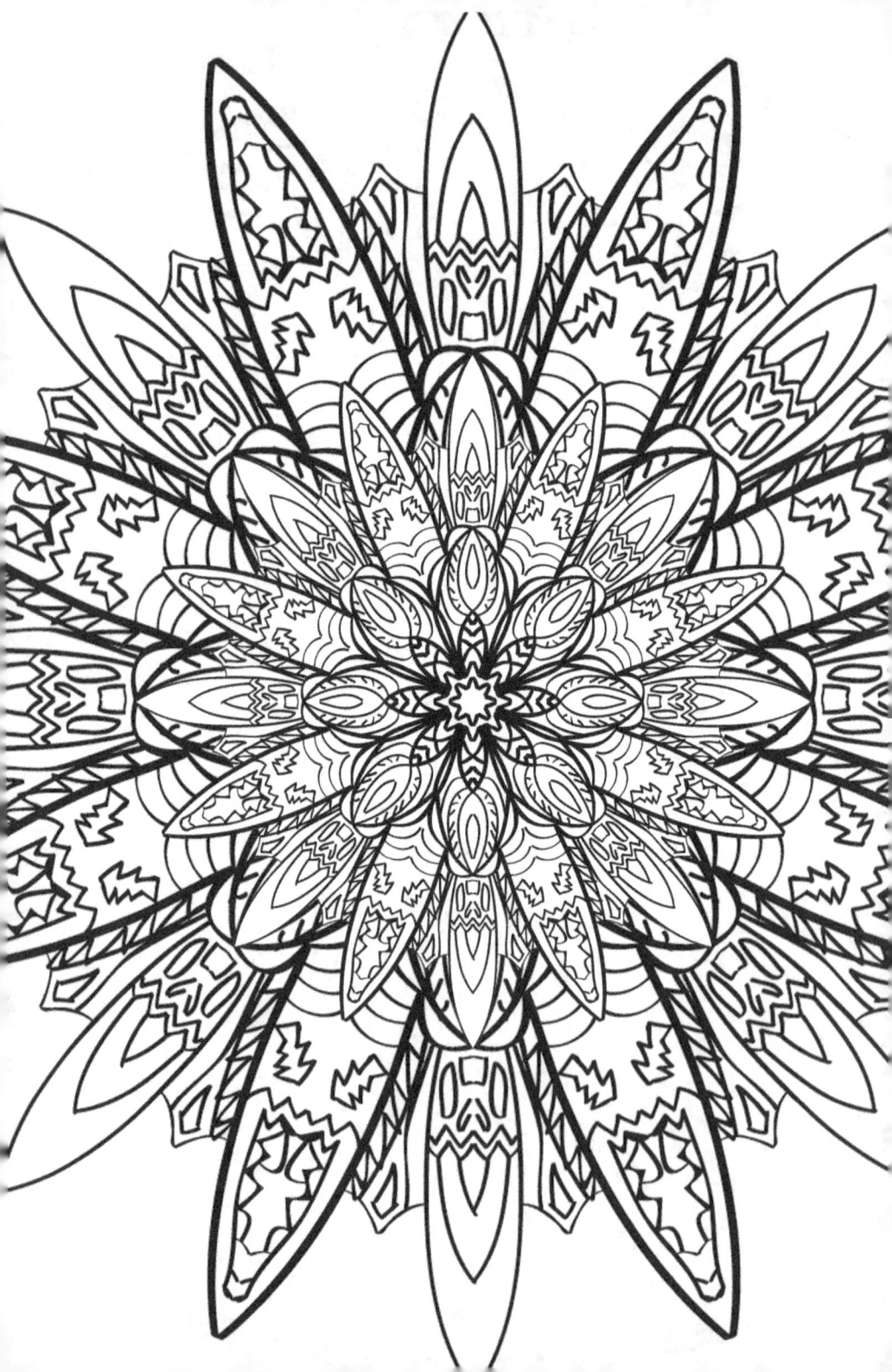

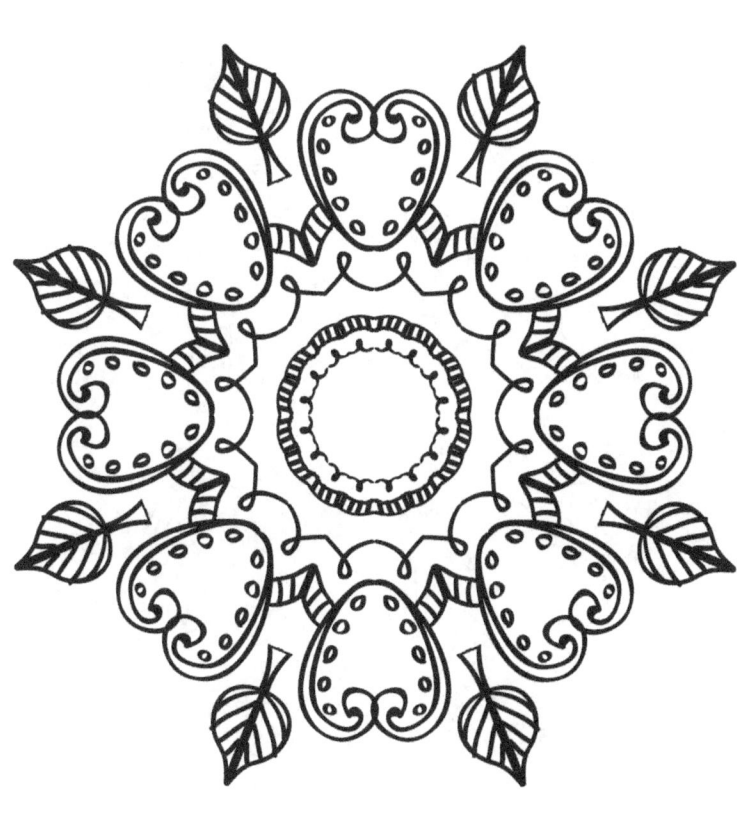

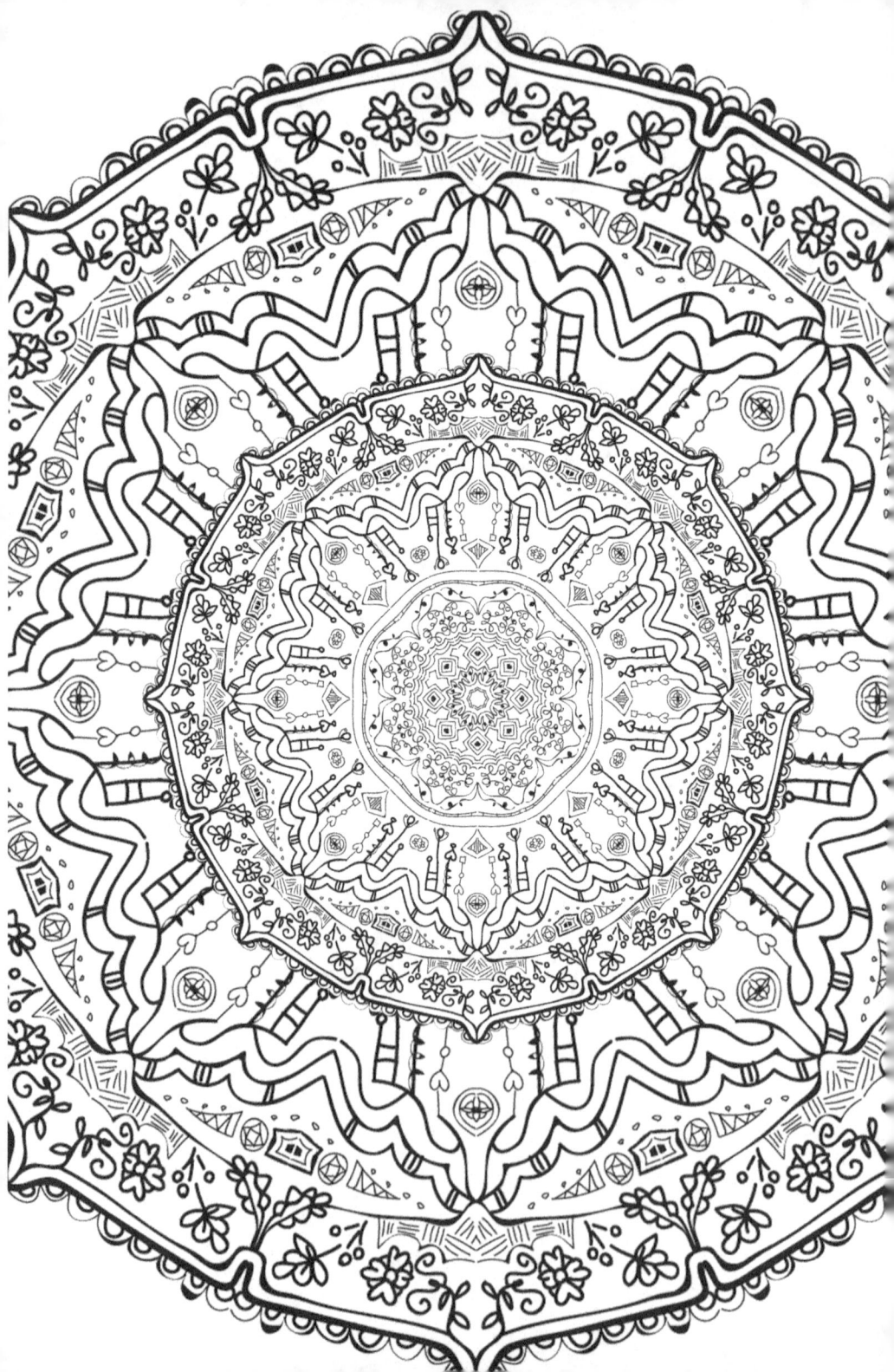

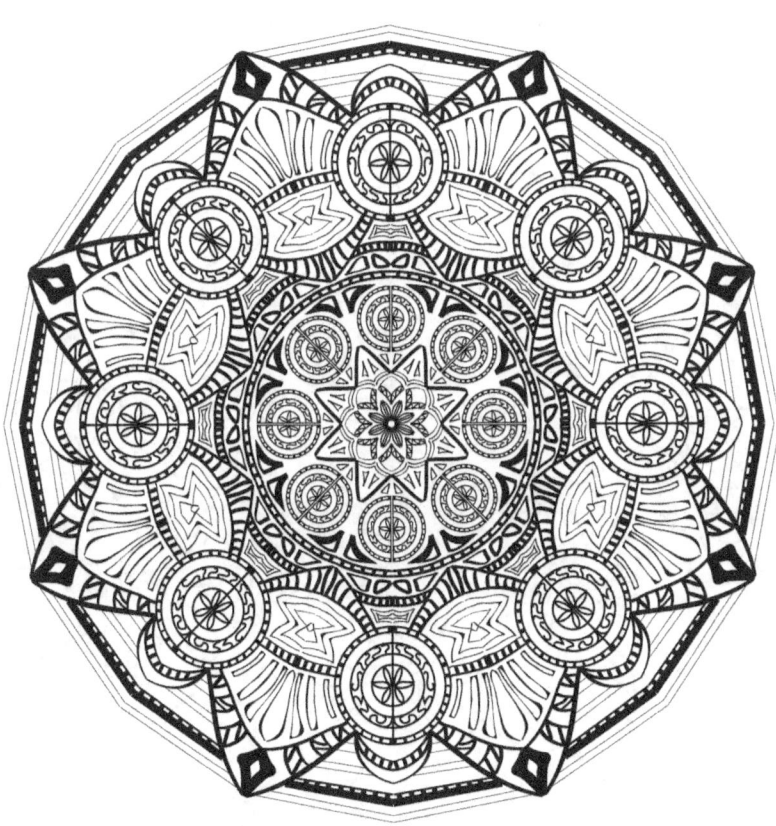

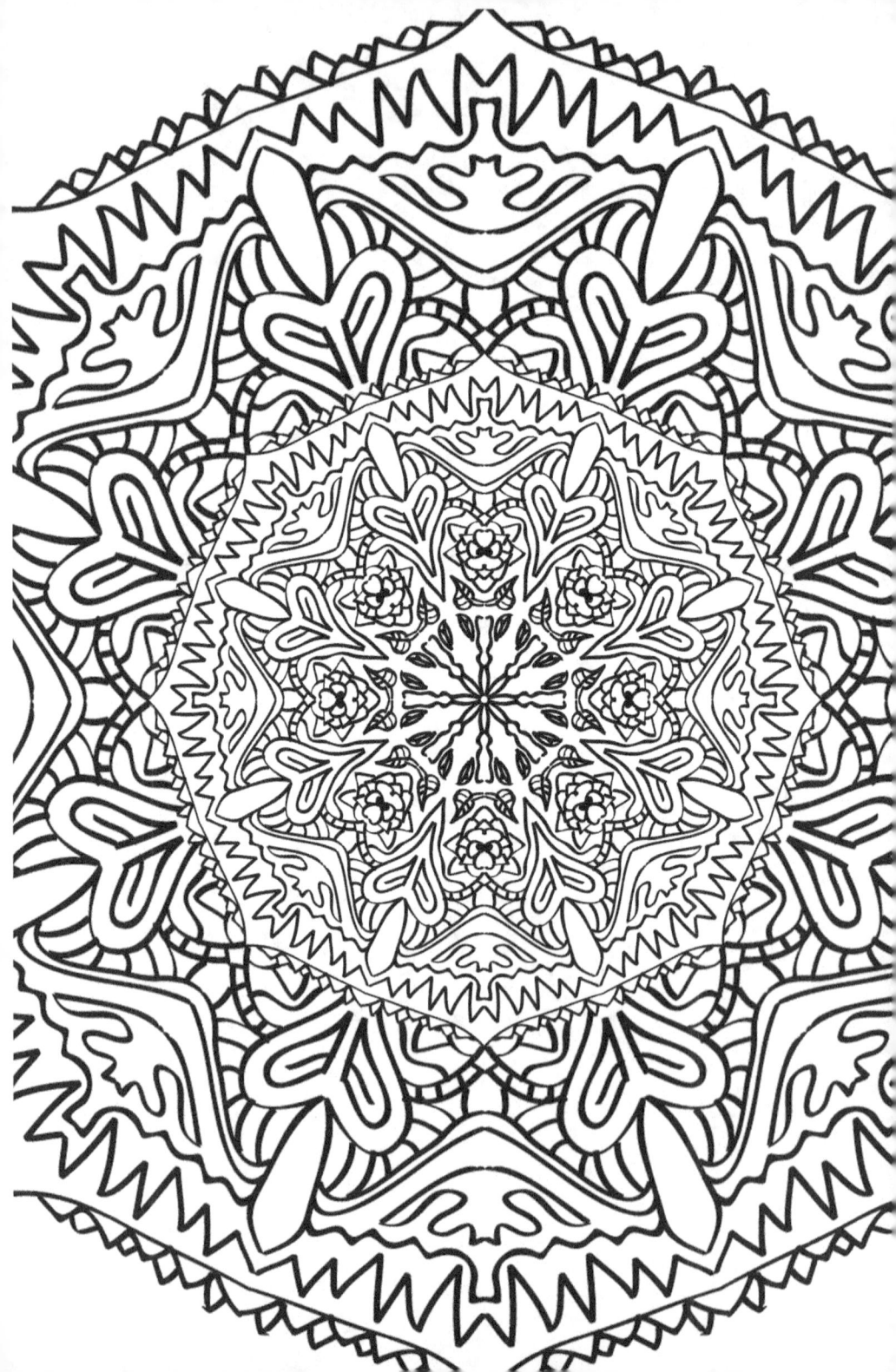

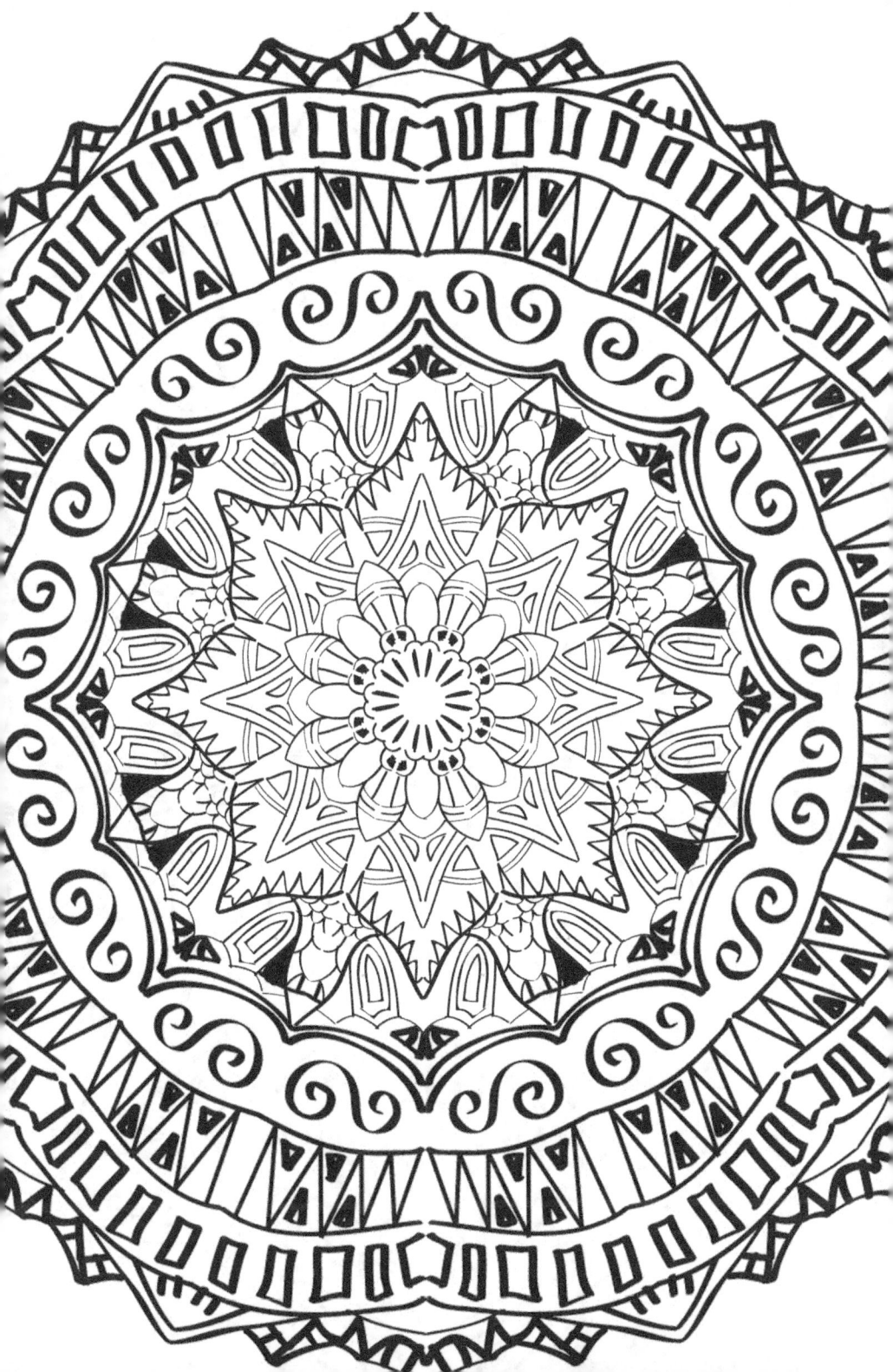

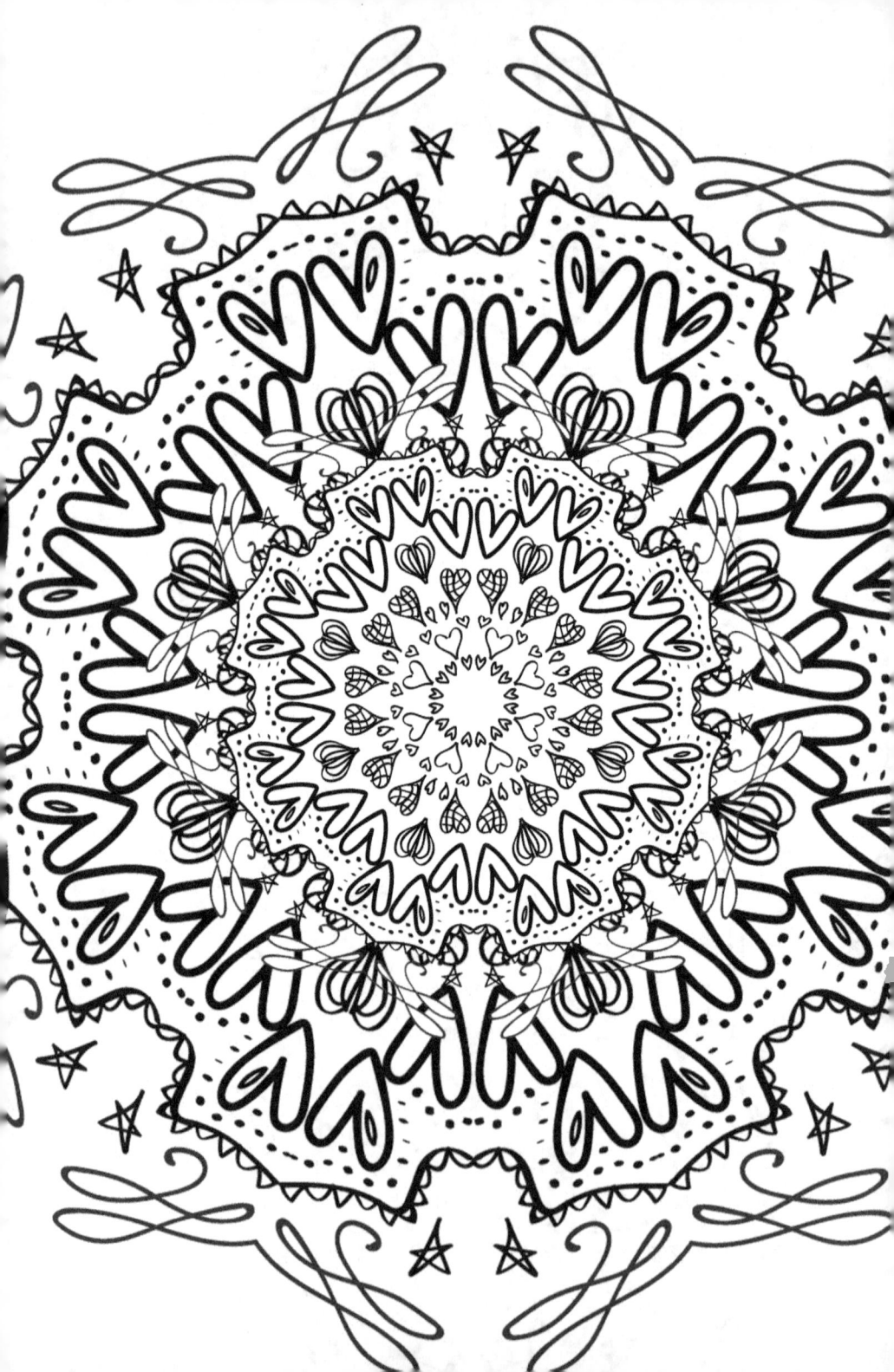

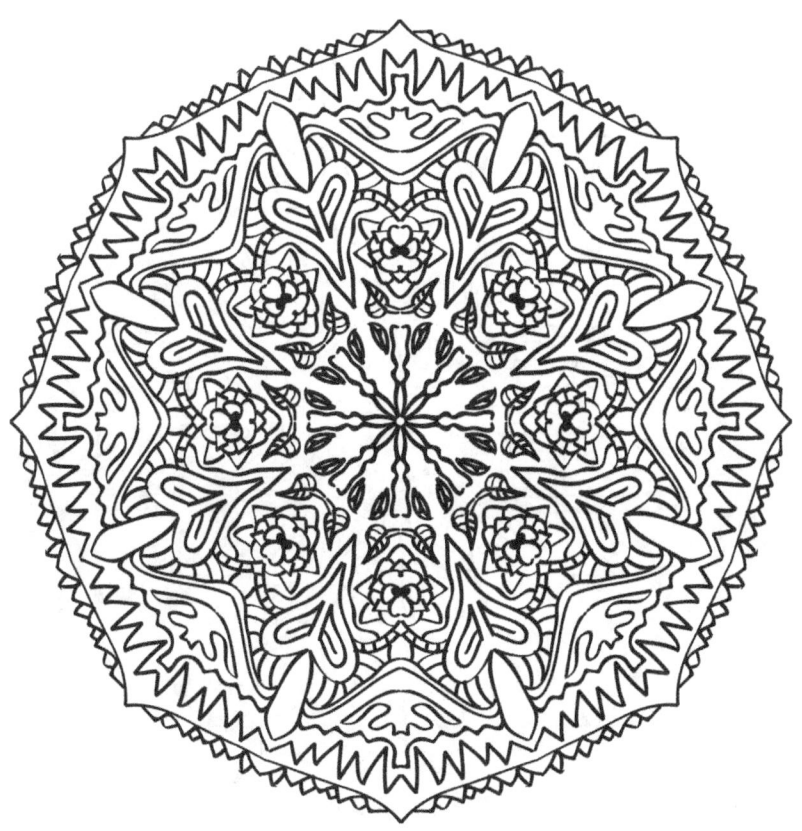

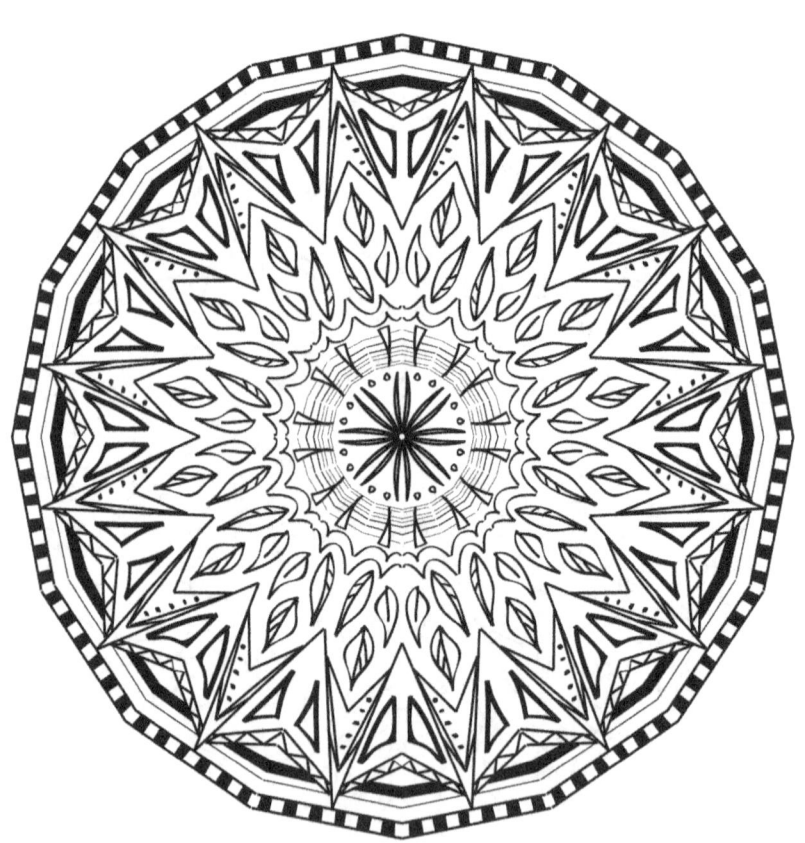

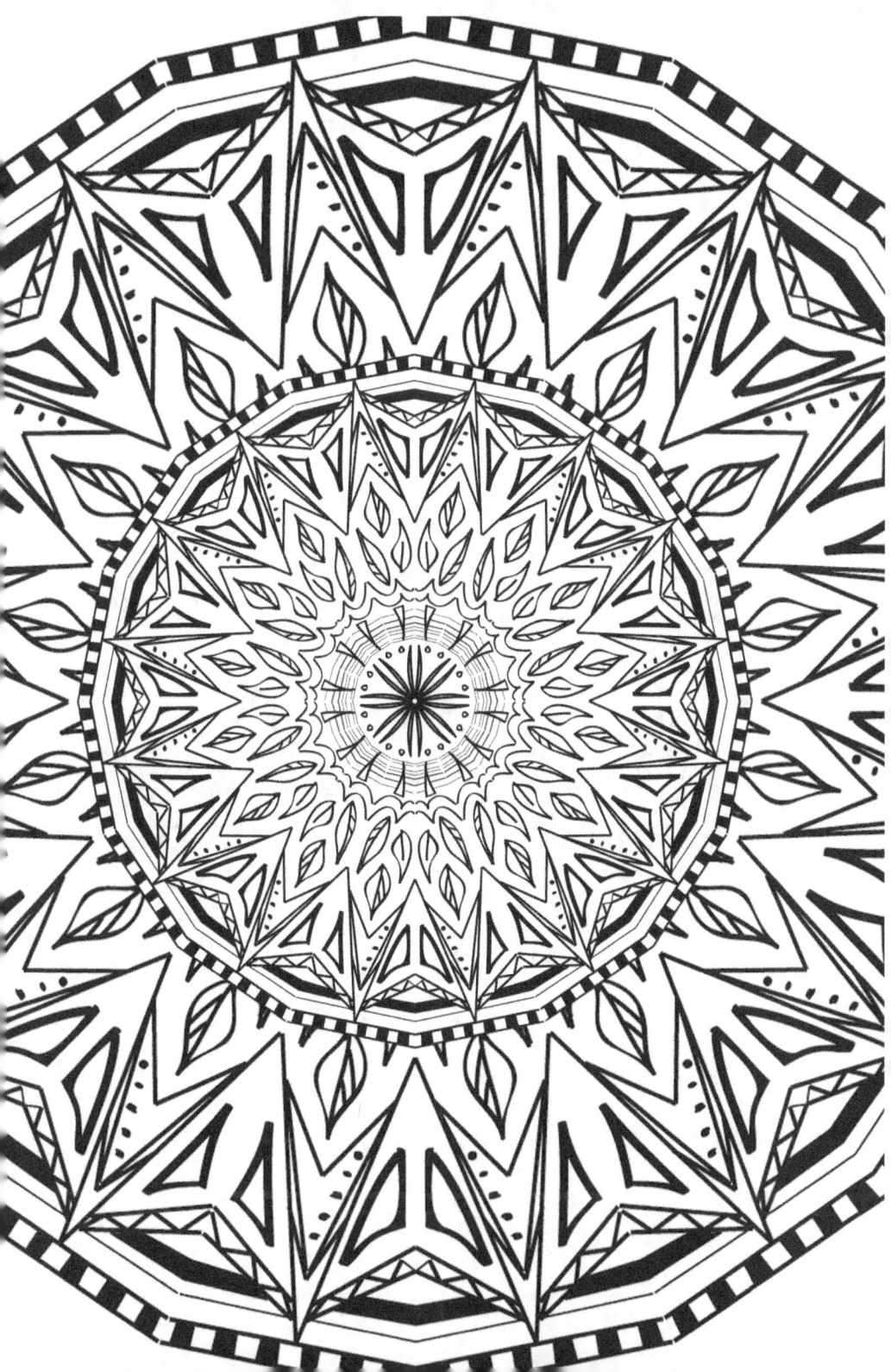

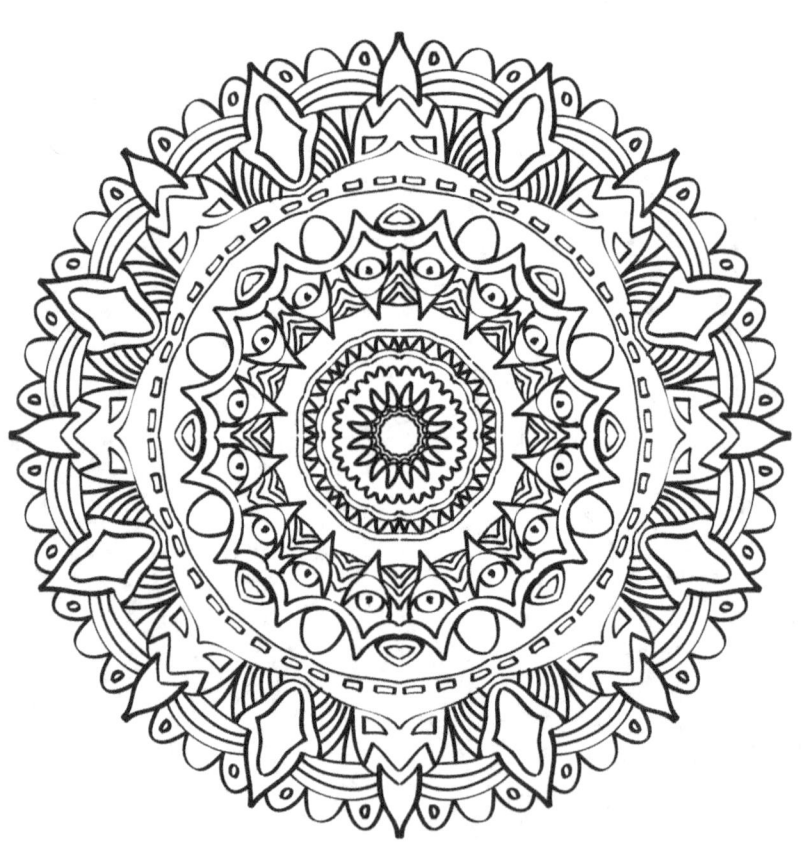

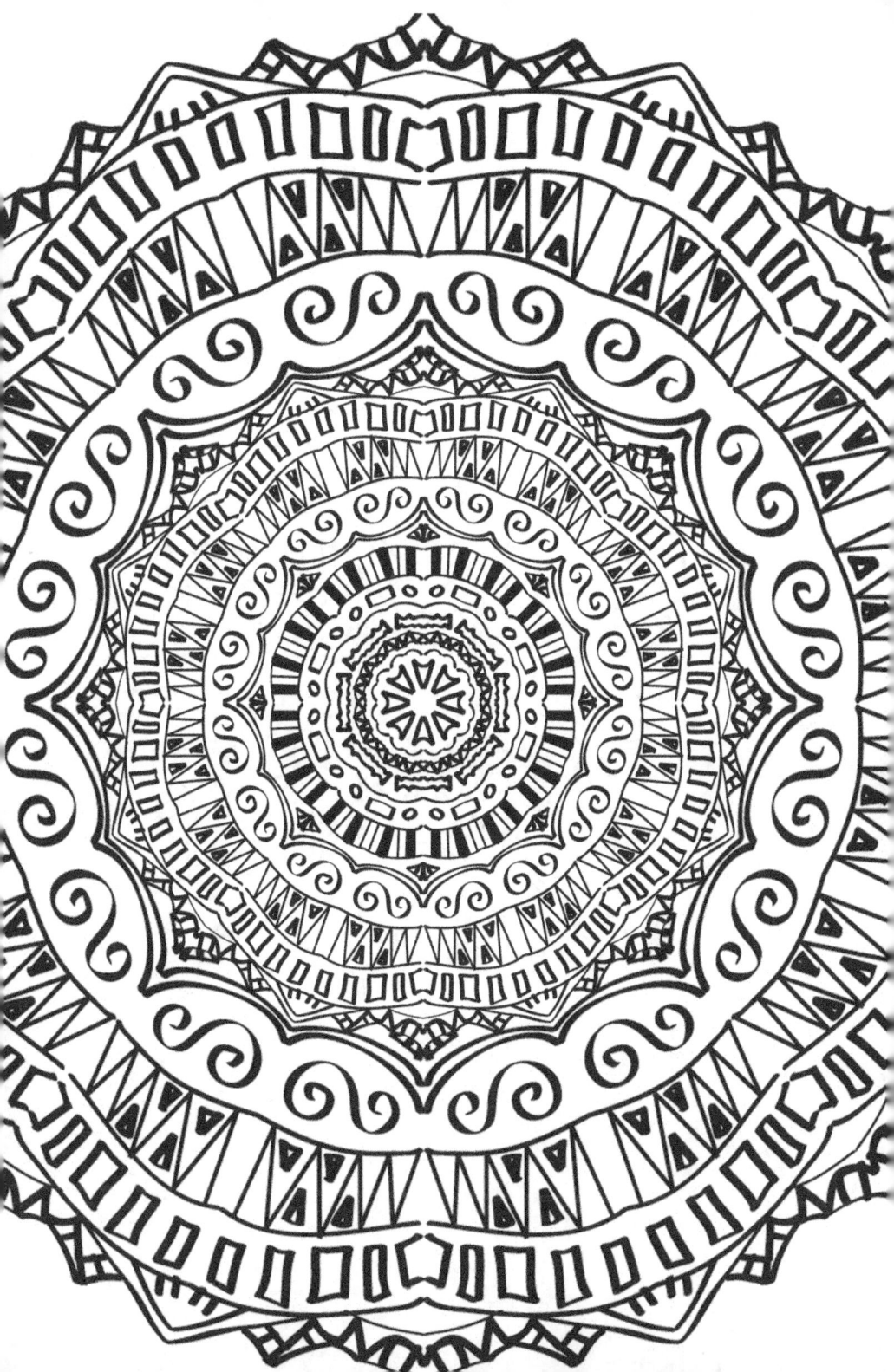

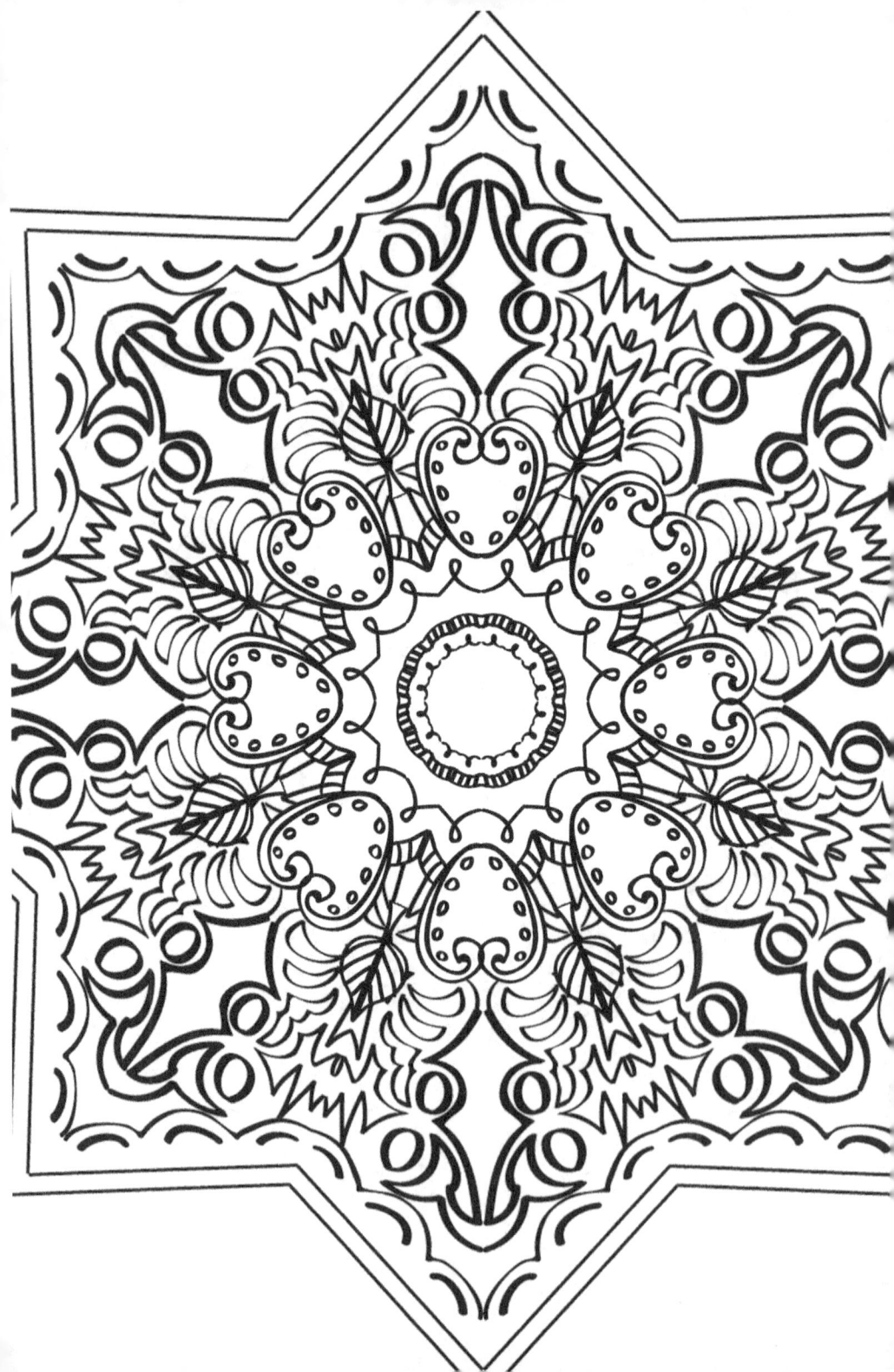

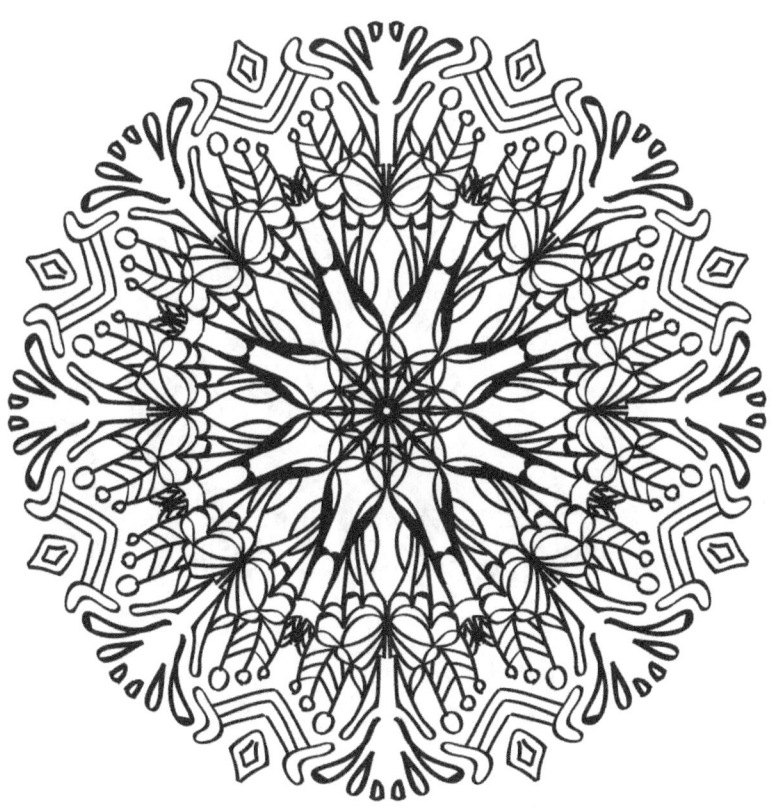

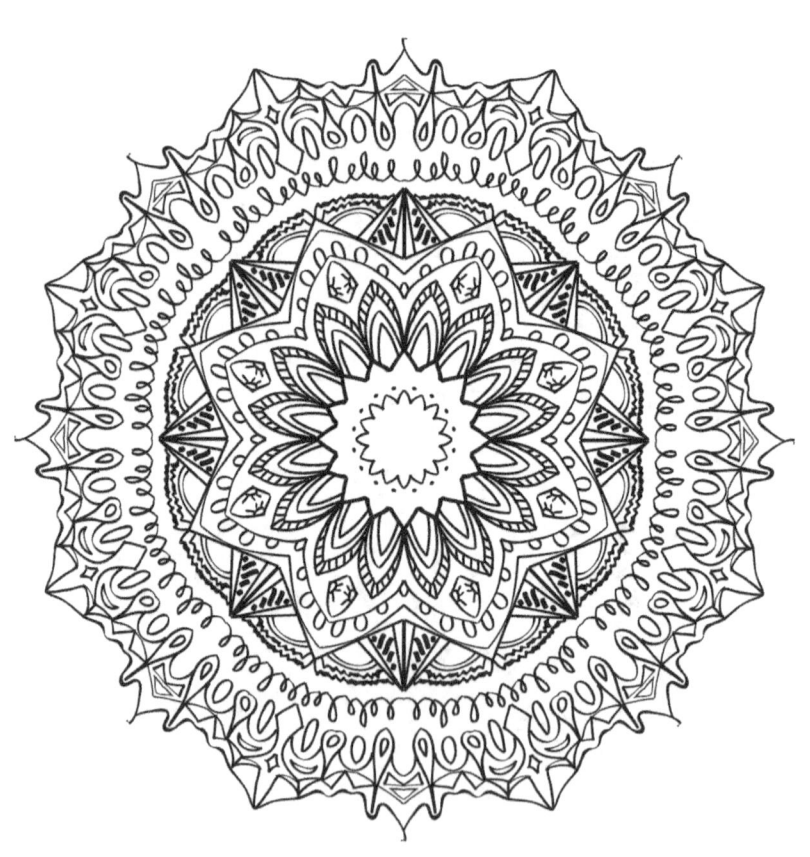

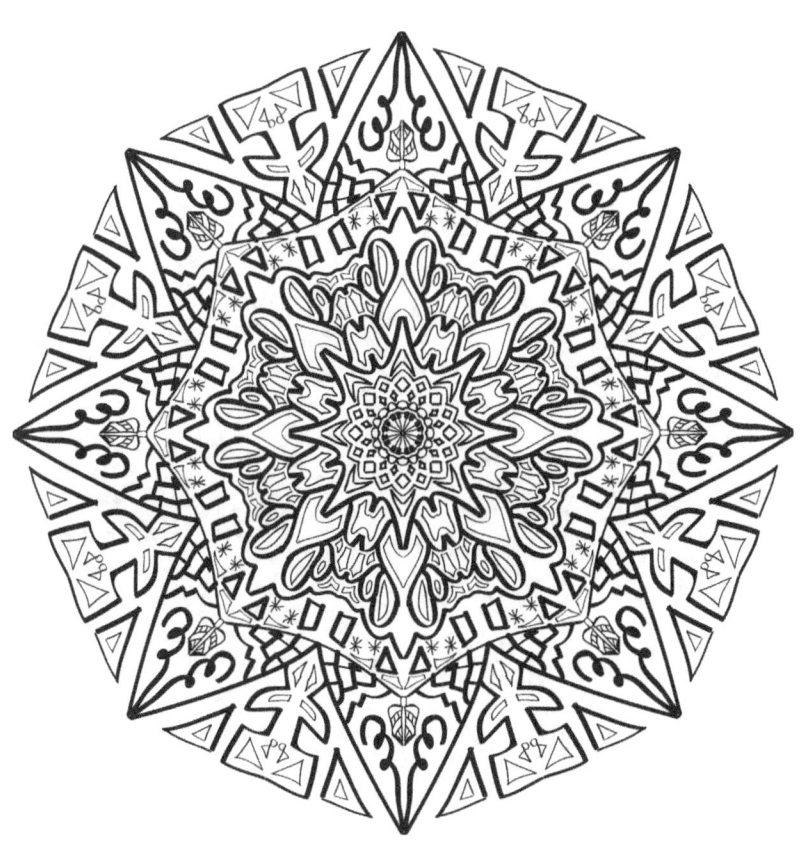

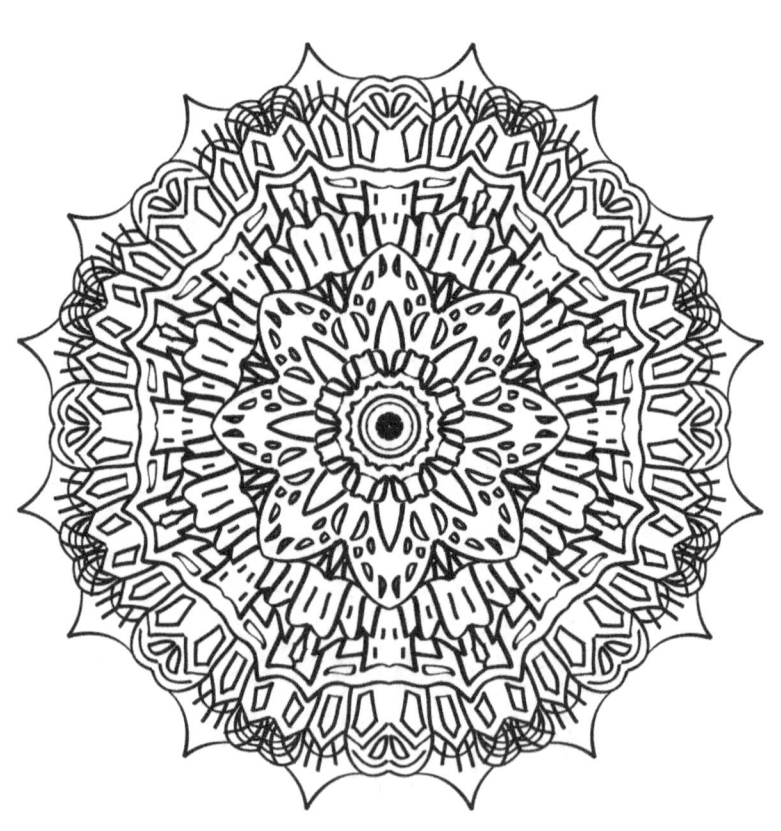

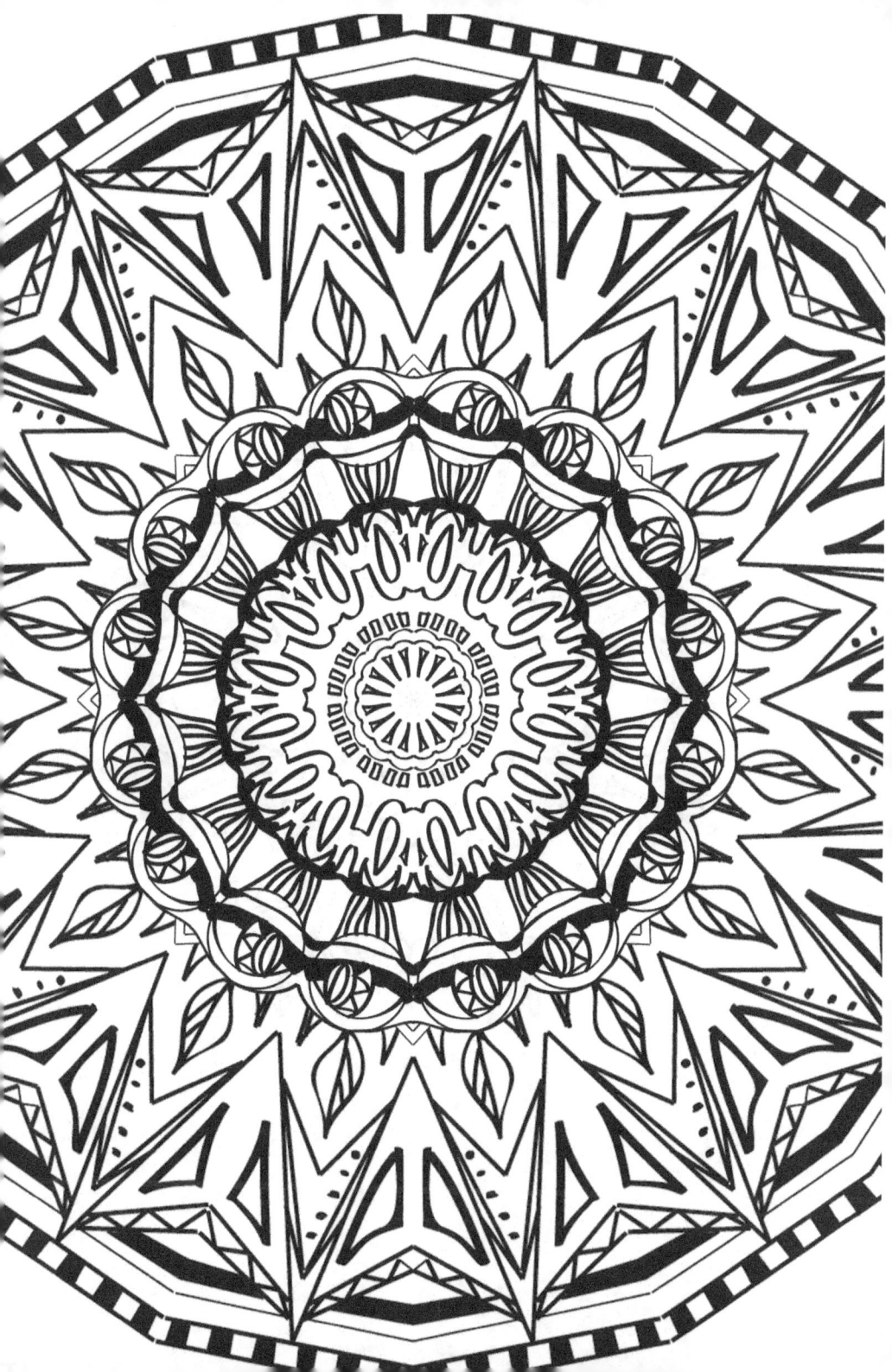

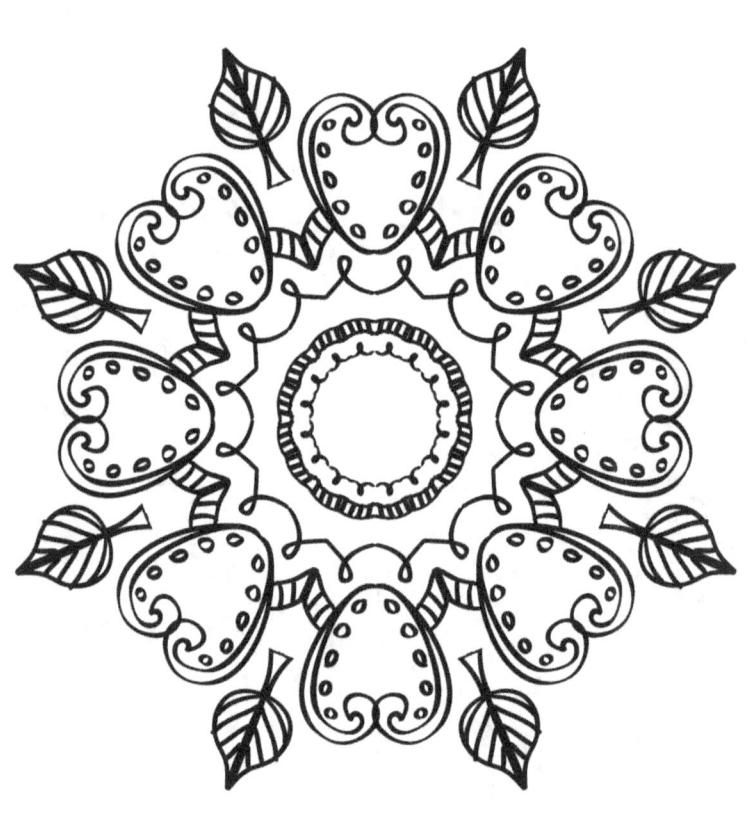

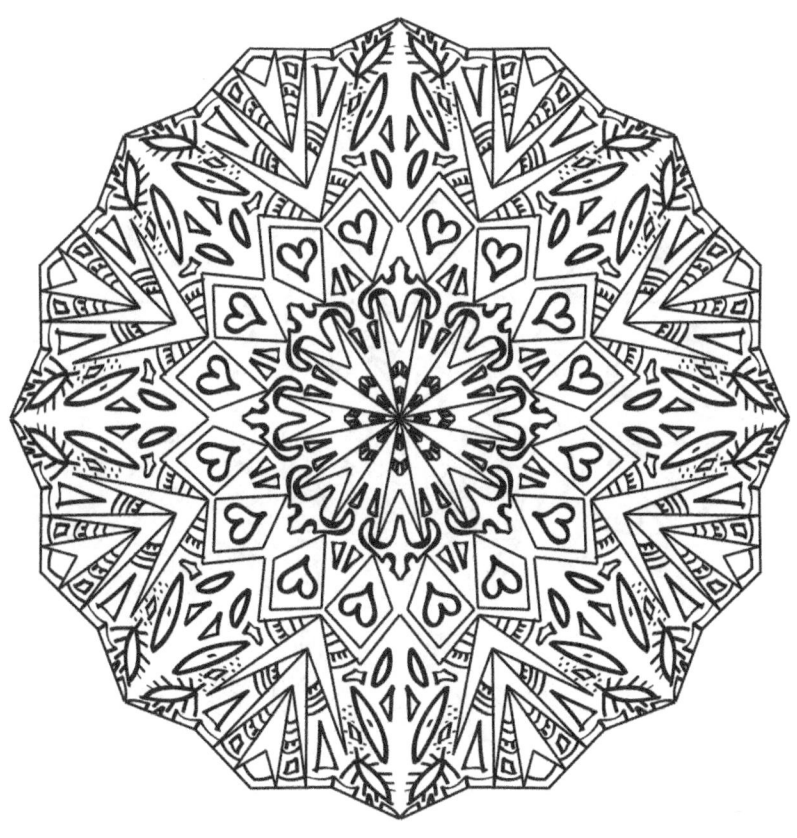

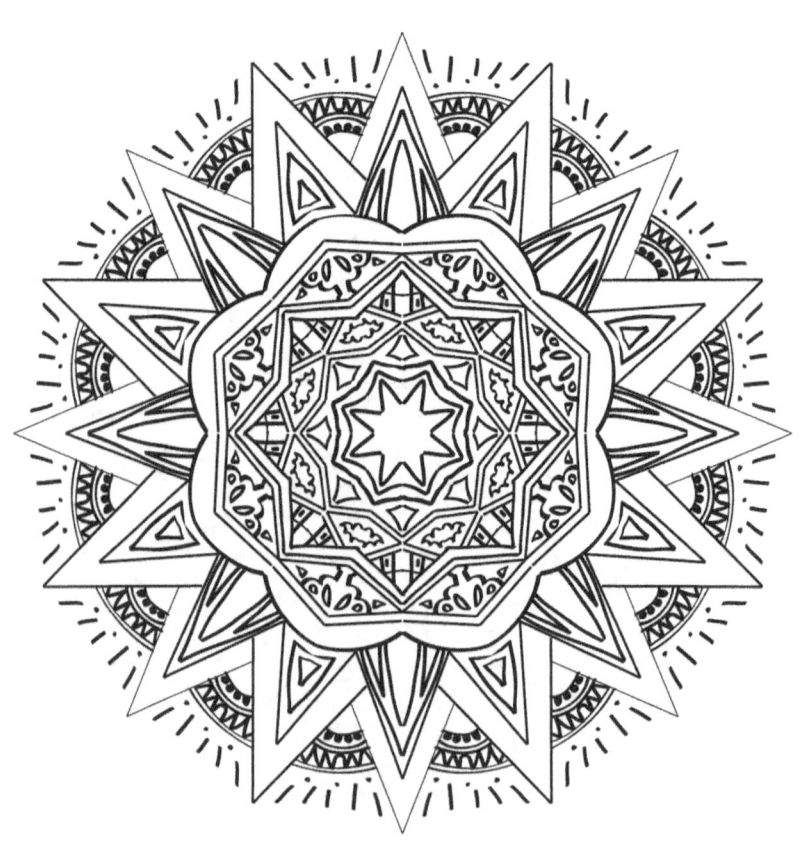

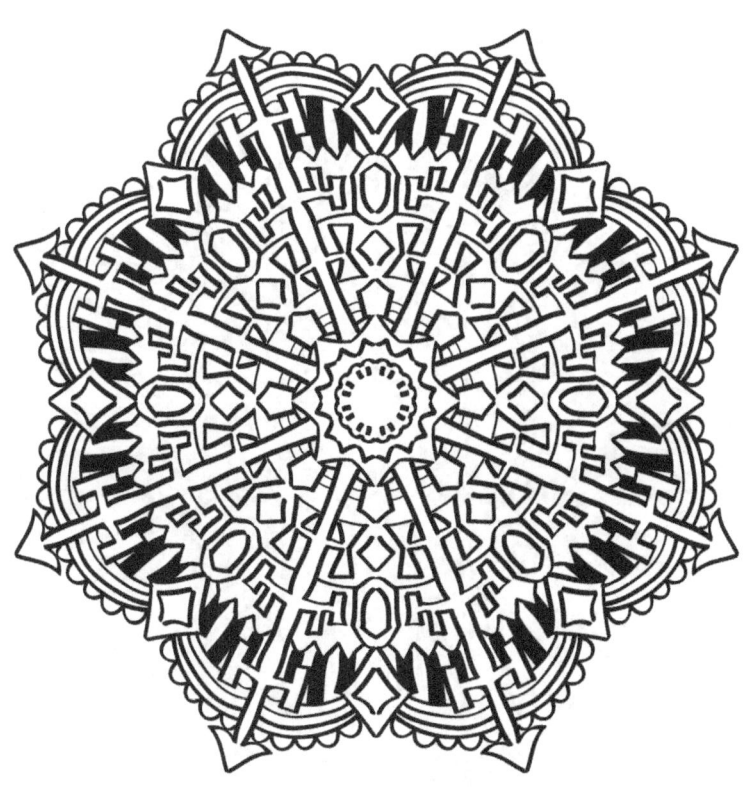

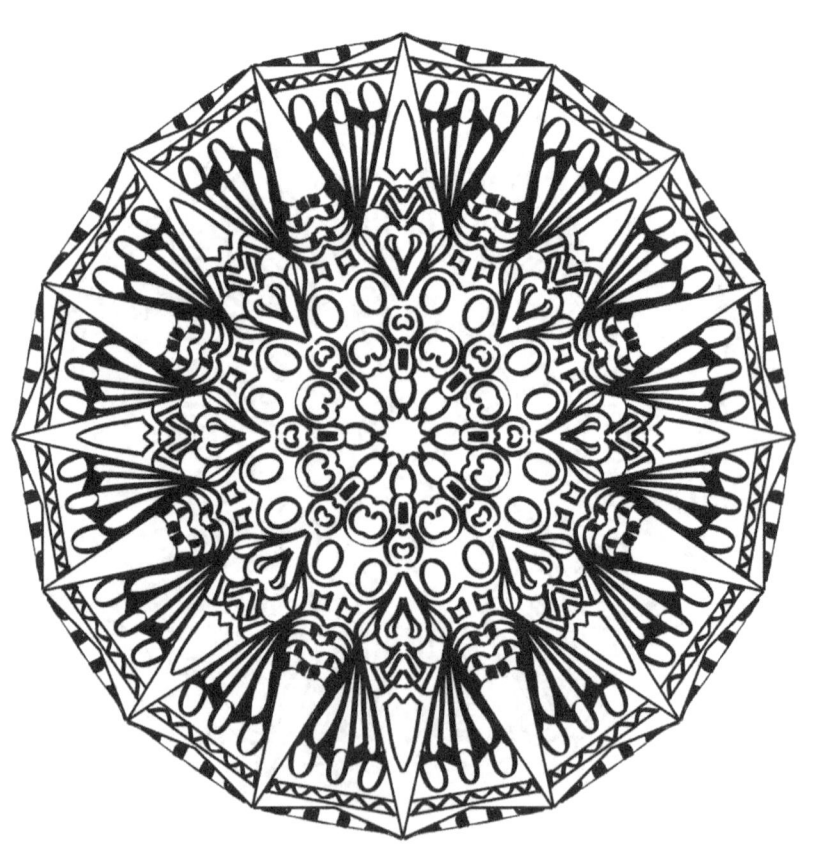

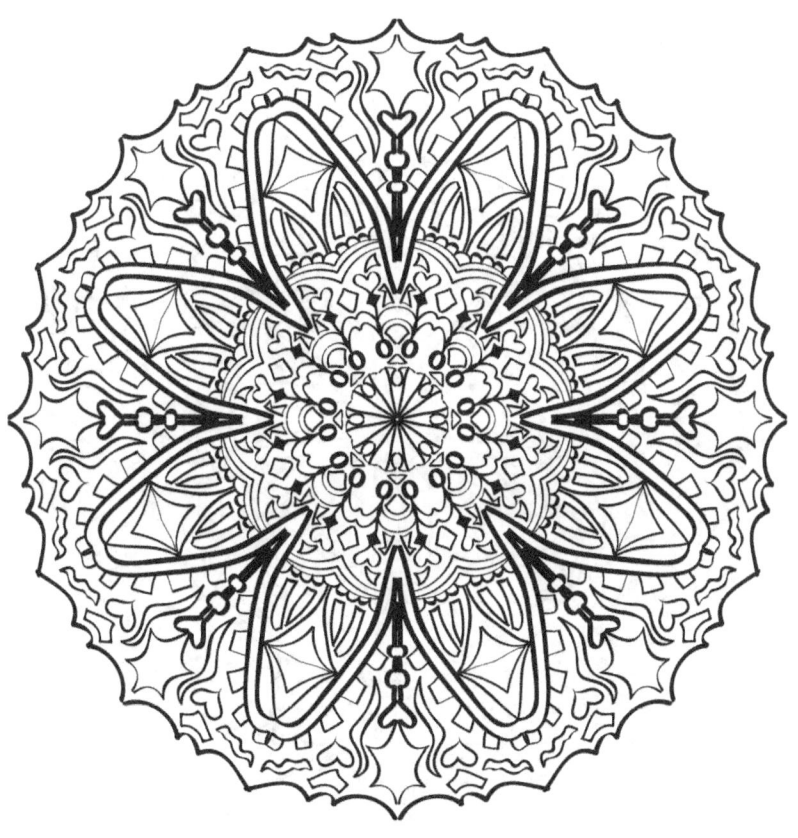

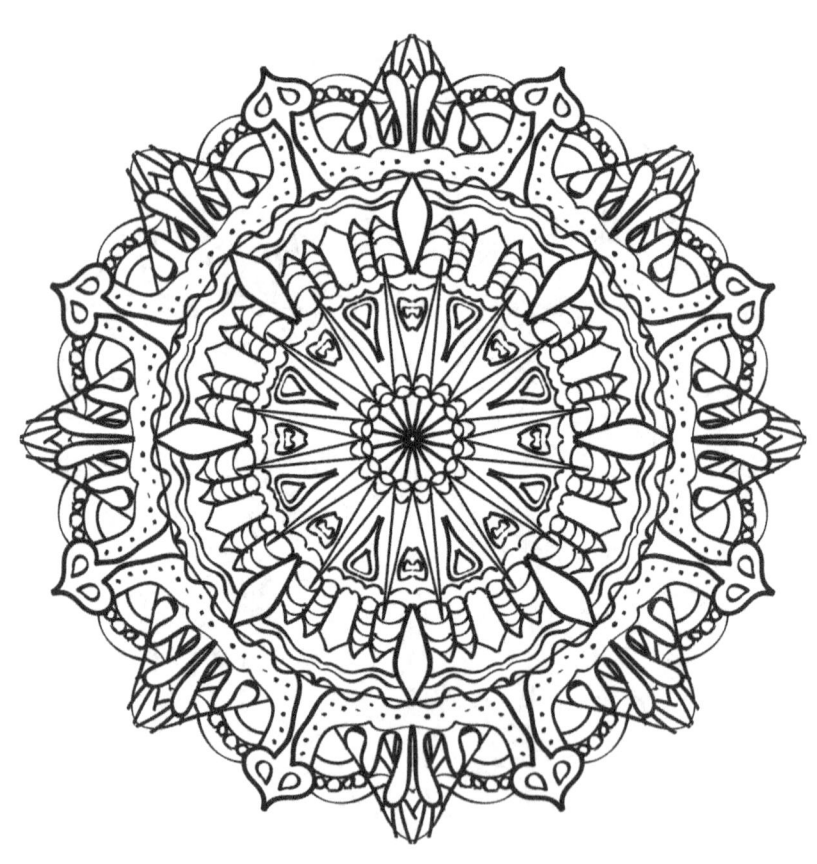

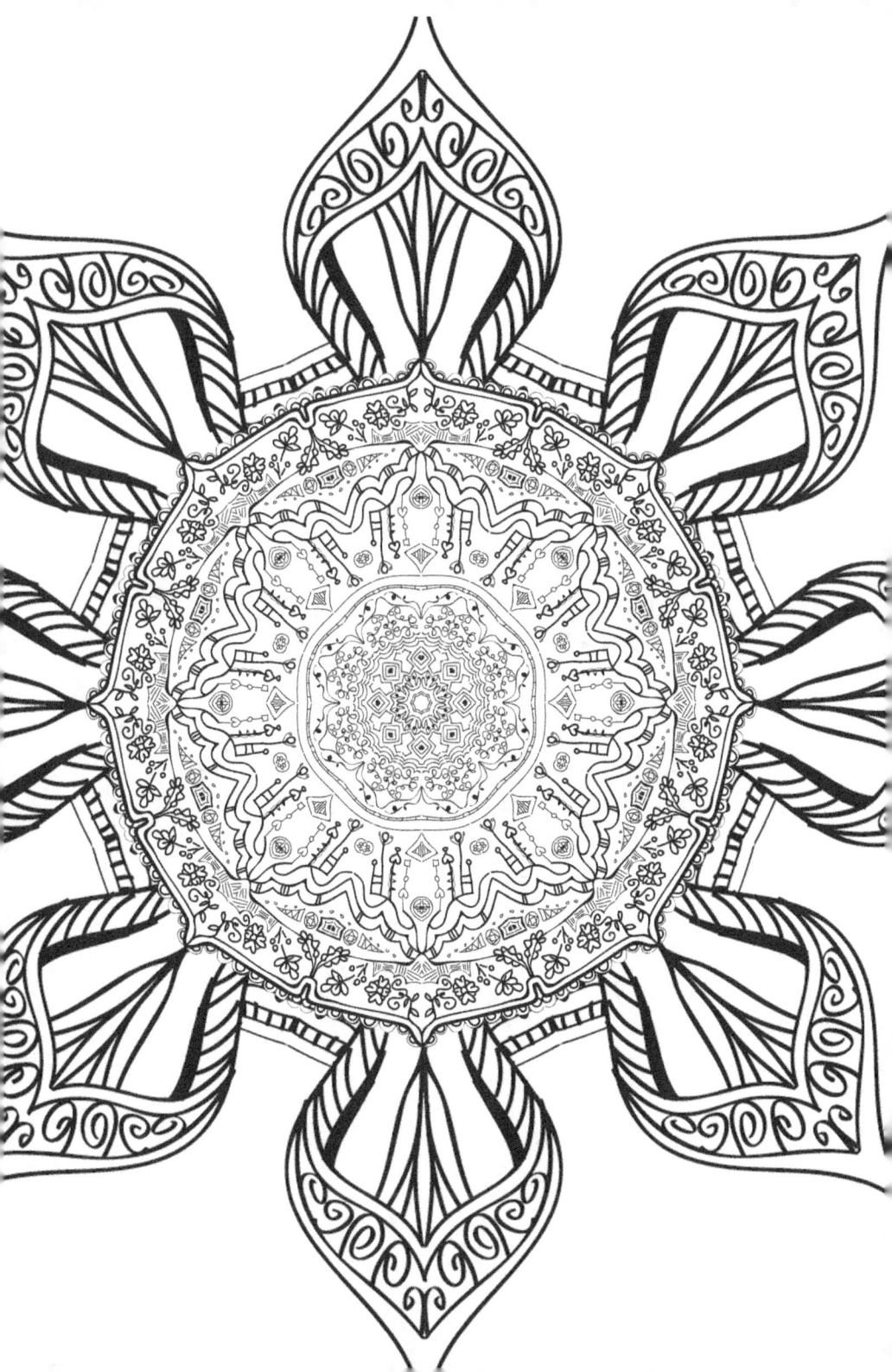

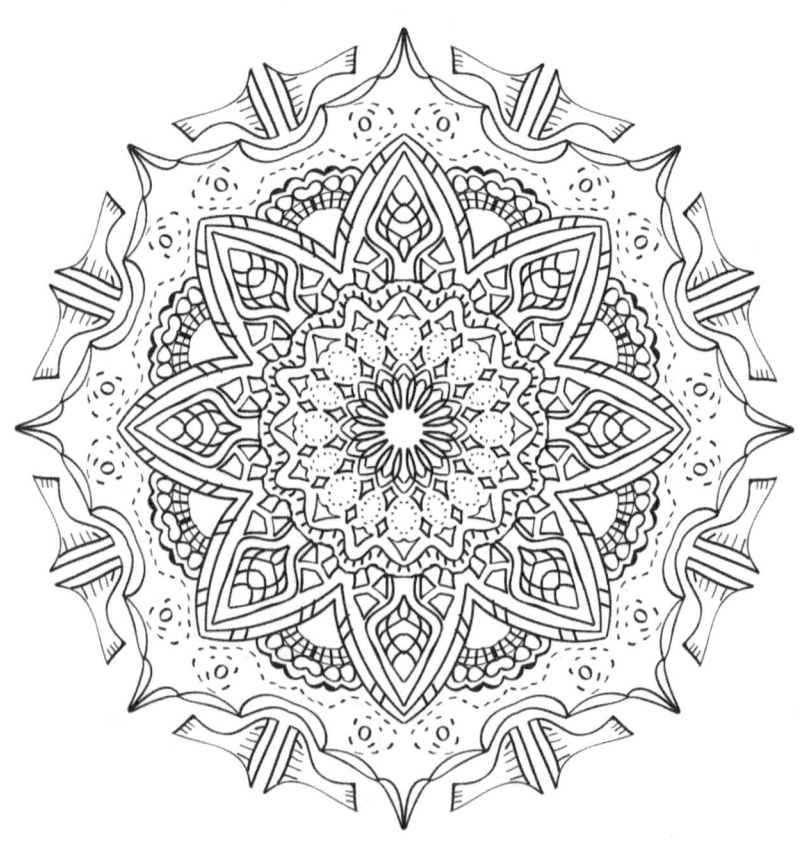

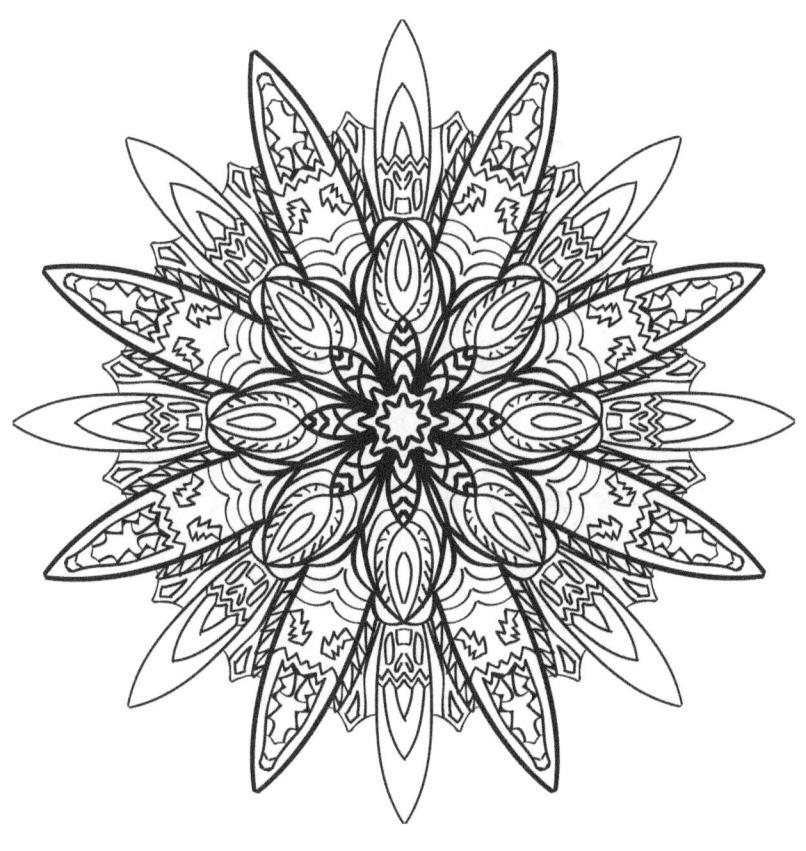

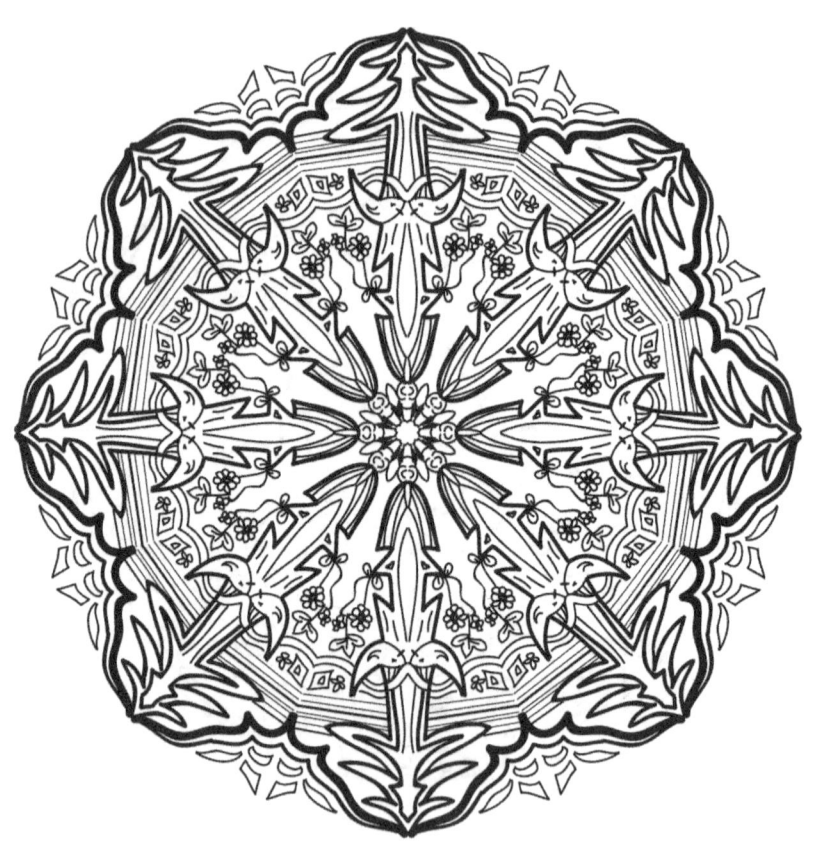

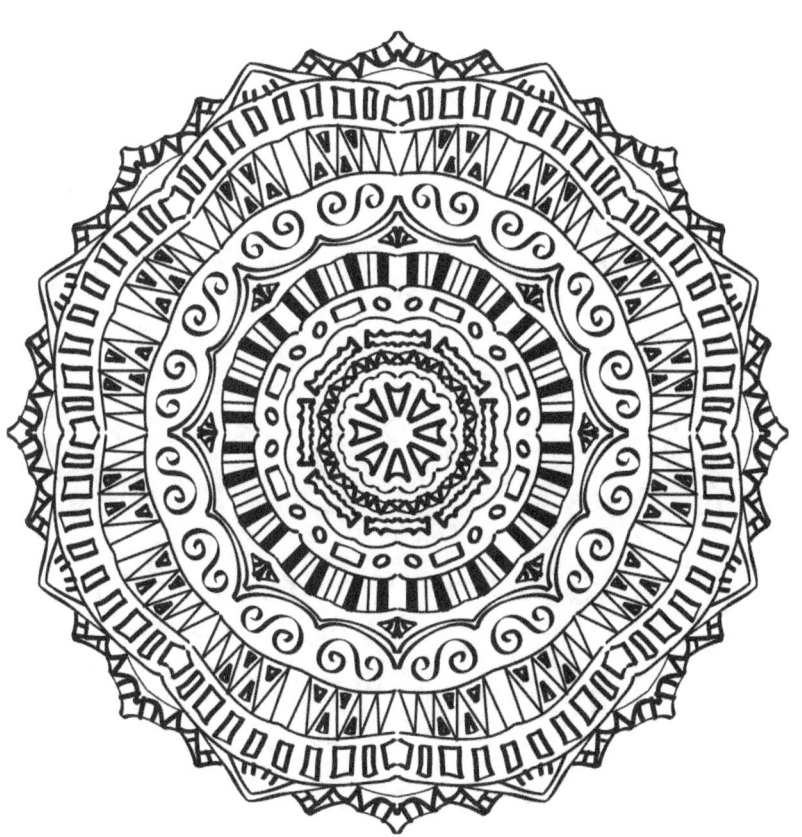

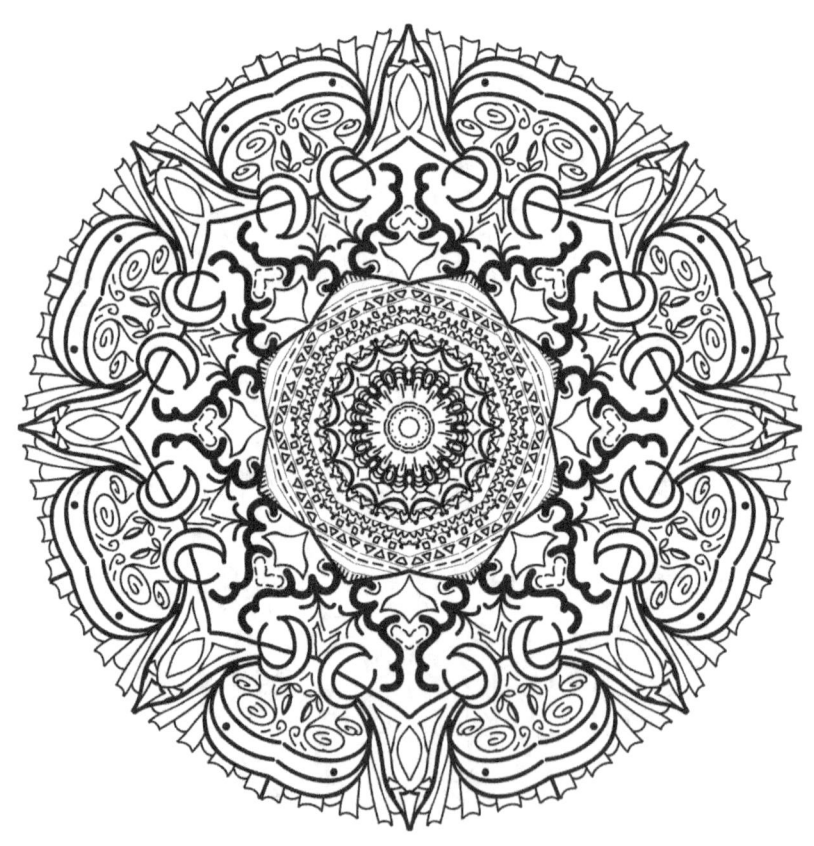

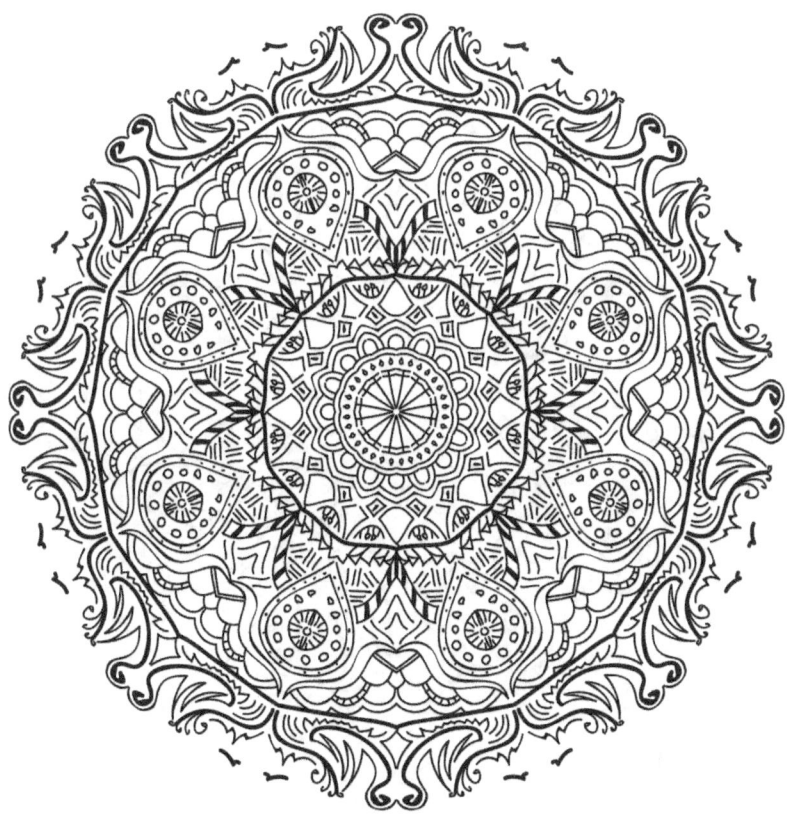

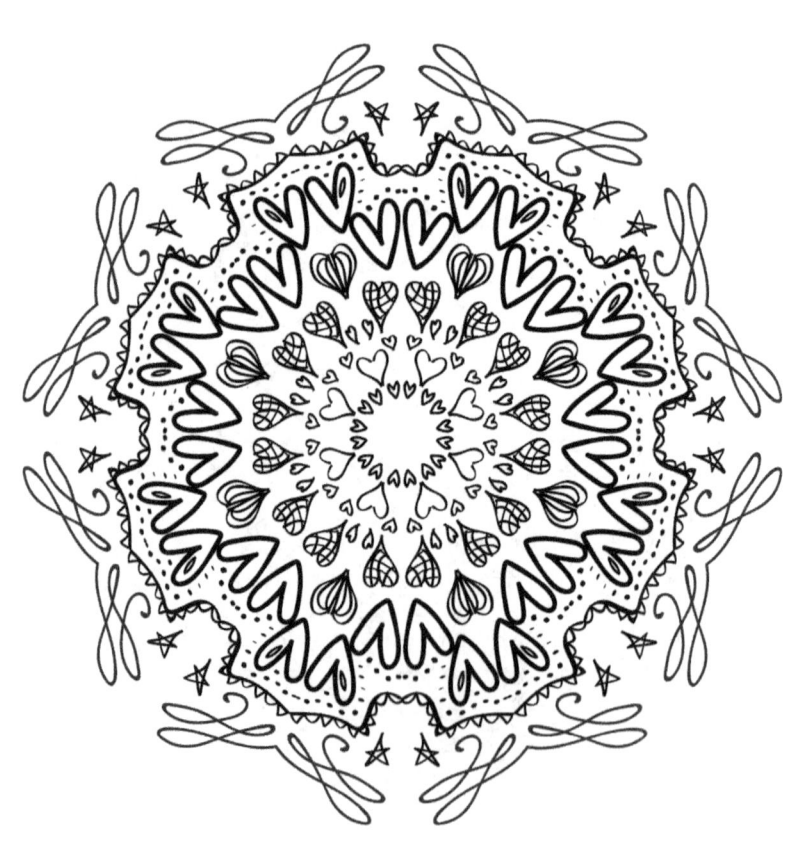

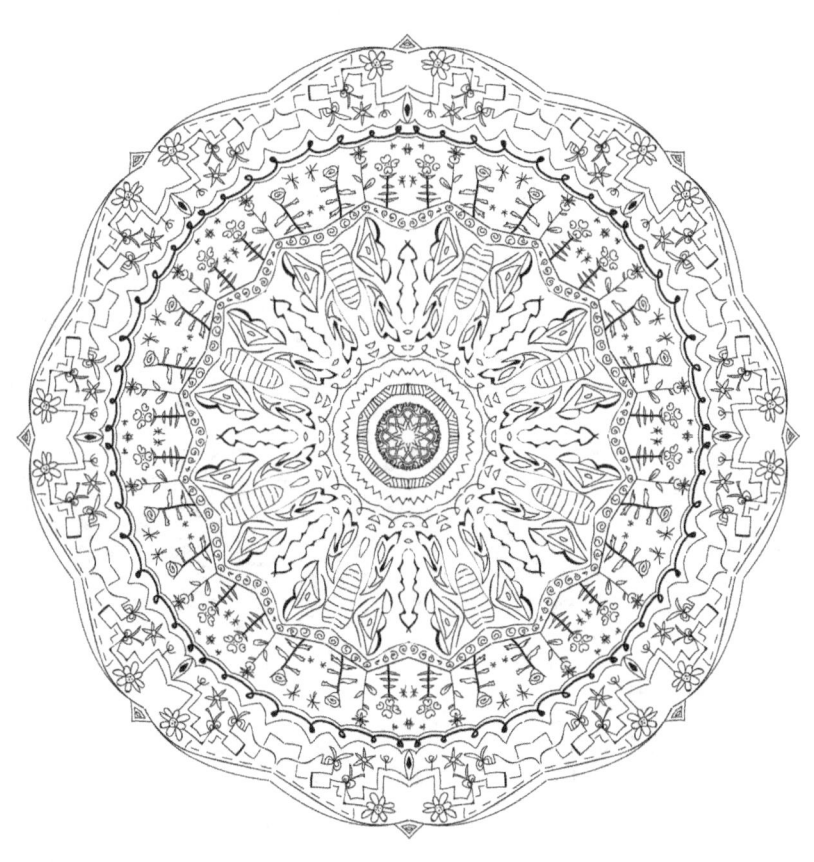

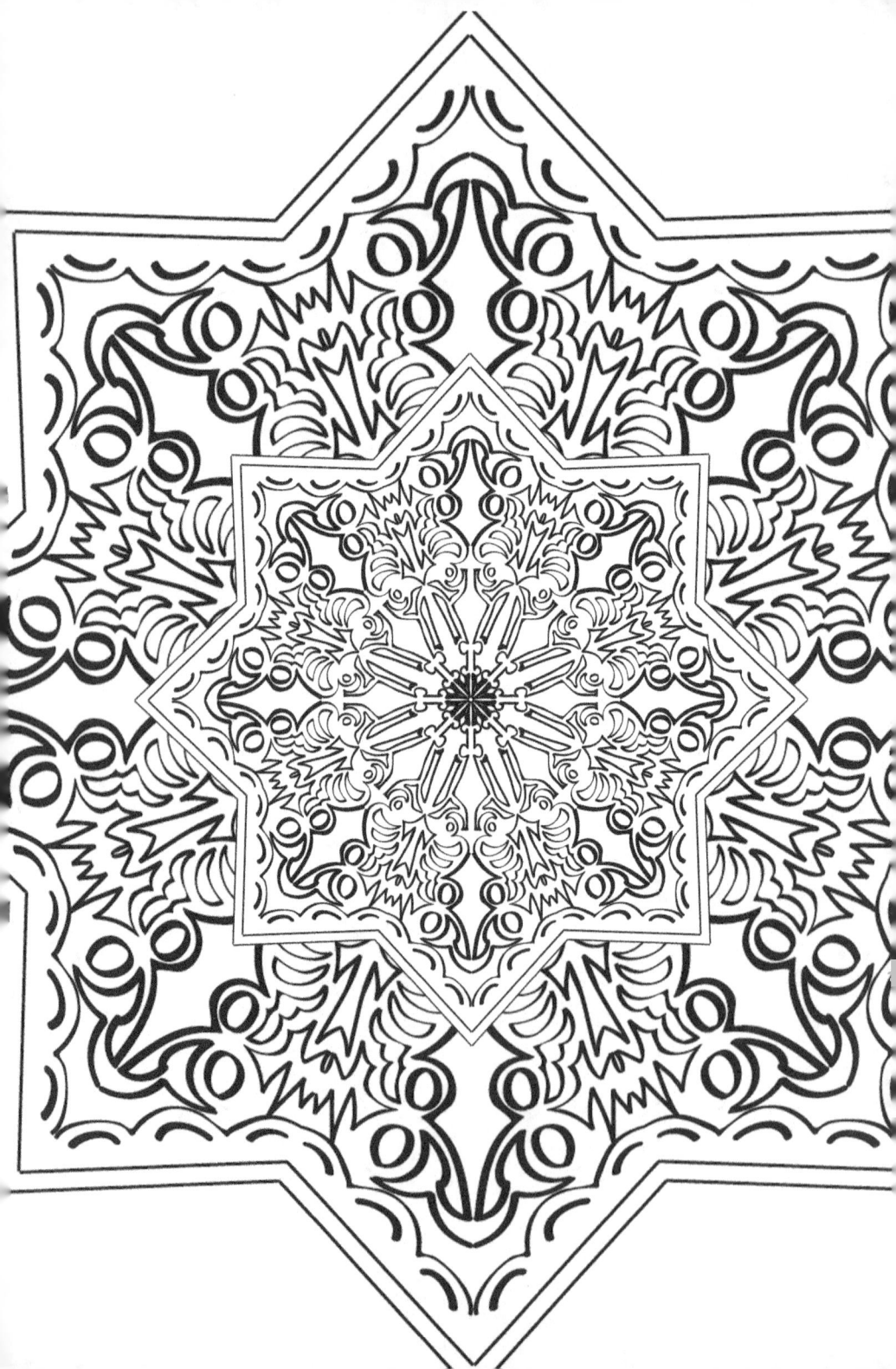

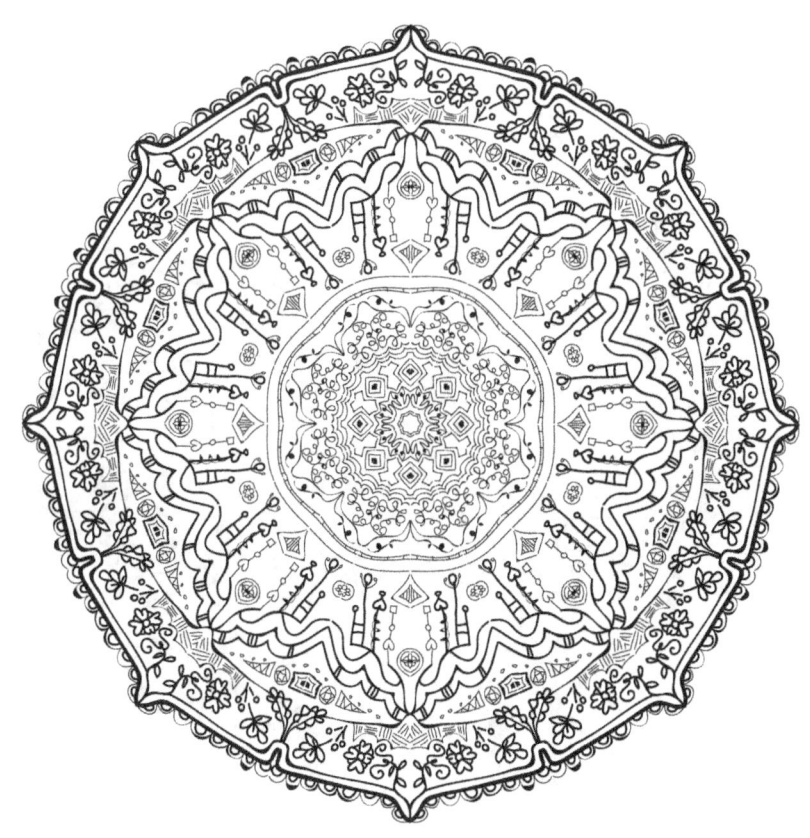

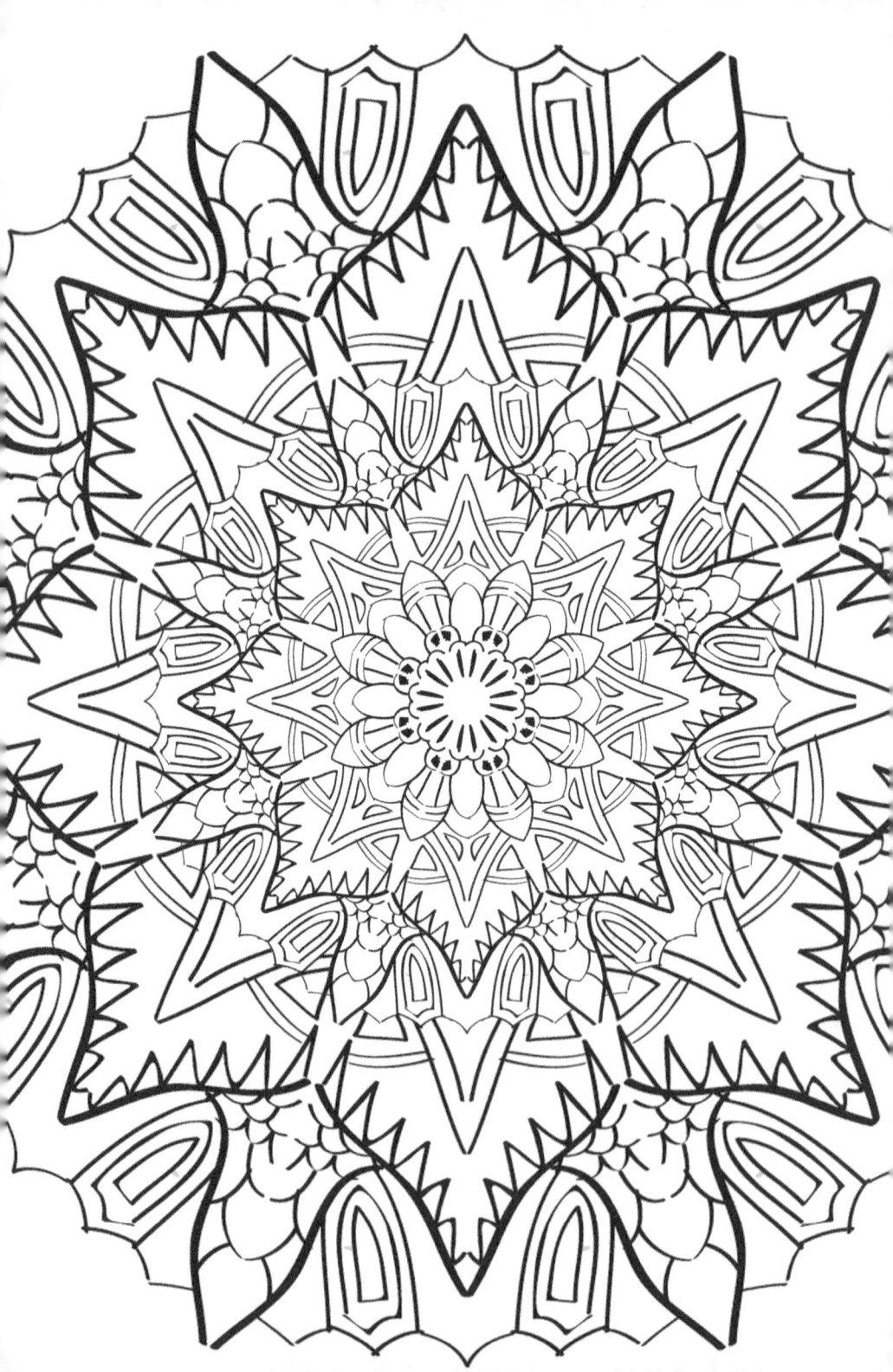

www.ingramcontent.com/pod-product-compliance
Lightning Source LLC
Chambersburg PA
CBHW072231170526
45158CB00002BA/843